# SECRET REDCAR, MARSKE AND SALTBURN

## Colin Wilkinson

AMBERLEY

First published 2023

Amberley Publishing
The Hill, Stroud
Gloucestershire, GL5 4EP

www.amberley-books.com

ISBN 978 1 3981 1497 5 (print)
ISBN 978 1 3981 1498 2 (ebook)

British Library Cataloguing in Publication Data.
A catalogue record for this book is available from the
British Library.

Origination by Amberley Publishing.
Printed in Great Britain.

# Contents

# Introduction

How secret were the activities of the smugglers that operated along this stretch of coast in the eighteenth century? An ancient tavern is the starting point for an exploration of the work of these gangs to try to uncover if this was really a secret army or if these 'free traders' were accepted and supported by a society happy to benefit from their work. Certainly, they had to act secretly to avoid the attention of revenue officers, but duty-free goods were distributed to all and sundry in the villages and farmland along this once isolated coast.

From these early days, attention turns to the emergence of the resort system. Each town brings a different story. Redcar and its neighbour Coatham were the first to attract visitors although, as the reminiscences of an early tourist tell, there was little by way of amusement. The arrival of the railway ignites growth, and a trip to the seaside becomes accessible to so many people. Saltburn provides a different story. It was the brainchild of a Victorian businessman who, whilst walking along the coast from his summer retreat at Marske, stopped on the clifftop above the group of fishermen's huts at Saltburn and imagined how a new, fashionable resort could grow around him. Plans were produced for streets of houses and grand hotels spreading out from the new railway station.

Marske also has its own story. For holidaymakers it was a quiet retreat, but this tranquillity was shattered by the discovery of ironstone in the local hills. Soon, mines opened and Marske was flooded with those attracted by the availability of work. Not able to cope with the growing demand for homes, another village had to be built.

Blast furnaces were constructed to process the ironstone until eventually they stretched along the banks of the Tees from Middlesbrough. These transformed the landscape and environment and helped to bring another role to these towns. The magnates of the iron industry escaped the chimneys belching out steam and flames and relocated their families to the fresh air at the coast and commuted to work.

As the twentieth century dawns, we find busy resorts bordered by industry and a new set of challenges. The First World War sees a strong military presence followed by the interwar years associated with industrial depression, unemployment and the Wall Street crash. Paradoxically, this was a time when the holiday industry was going from strength to strength. Why was this, and did these towns respond to the opportunity this gave them and to the challenge of providing the facilities expected of a modern resort?

There will be other stories, including an early telephone system in Saltburn. What was suffragette Emily Pankhurst and Keir Hardie, the founder of the Labour party, doing in the area? However, before the stories of explosions, misunderstood vicars, early trade unions, heroes and Hellfire Clubs are uncovered, there is a little history of the area with some stories that perhaps were best kept quiet.

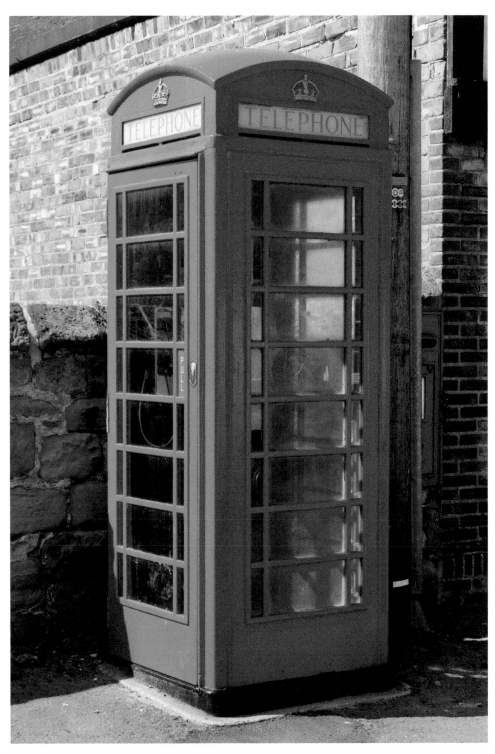

Why has this red, cast-iron telephone box in Marske survived? Surprisingly it has been given the status of a listed building.

# 1. Early Days

Pennyman, Dundas, De Brus, Zetland, Turner and Newcomen are all names associated with the three towns, but to find their place in history we need to go back to the days of the Norman invasion. In 1069, William the Conqueror's stronghold at York was attacked by Northumbrian rebels. The retribution was harsh and devastating. A force was sent into the countryside above York to remove the unruly population and destroy their villages and livestock, leaving those who survived facing starvation. This was the Harrowing of the North; its impact can be seen in the Domesday Book, the survey and valuation of the King's land conducted in 1085. There was little to be found along the stretch of coast between the mouth of the Tees and Huntcliffe. Marske is mentioned with twenty-six villagers, whilst much of the surrounding area was described as waste.

...To strengthen his position in the north, William's son Henry I granted extensive estates to Robert de Brus. Robert established a base at Skelton Castle and his holdings passed down through the family until Peter de Brus died in 1272 leaving no children, so his four sisters were left his estates. Two of the sisters inherited lands that are of concern here. Lucia inherited Kirkleatham, which stretched down to the coast to Coatham. She married into the Thweng family, and with her went the estate. Her granddaughter, another Lucia, was a colourful character; her marriage to William de Latimer had been arranged by Edward I, but this royal involvement did not stop her turning up for her wedding pregnant, most likely by her cousin Marmaduke Thweng. Within a year, she tired of her husband and was back with Marmaduke; however, she soon deserted him to attract more admirers, including Nicholas Meynell, Lord of Whorlton, and this relationship produced another illegitimate child. Latimer eventually divorced Lucia, and she went on to find two more husbands.

The estate was passed down the Thweng line, until by marriage it went to the Lumley family. John Lumley lost the land and his life after he became involved in the uprising known as the Pilgrimage of Grace. Henry VIII's break with the Catholic Church, which brought the closure of monasteries and disruption to the established religious order of the country, triggered this rebellion. The revolt broke out in the northern counties in the autumn of 1536 and once the king had strengthened his forces in the north, he took retribution on the ringleaders. Among them was John Lumley, who spent time in the Tower of London before being executed. The Crown confiscated the estate, and it was acquired by Sir William Bellasis, who in turn sold it to John Turner and Kirkleatham became a base for the Turner family. John's son, William, used much of his wealth to help the poor, including building the hospital and a free school at Kirkleatham. William was a successful wool merchant in London and, for a time, served as Lord Mayor. He moved in the same circles as Samuel Pepys, and when William received a knighthood, the famous diarist was able to note 'Mr Turner, the draper, I hear, has been knighted.' This

was rather muted praise, despite William's brother John being married to Pepys' second cousin. Pepys often wrote of his cousin Mrs Turner and her daughter Theophillia; when her brothers were in London, Pepys commented that they had grown 'into very plain boys after being under their father's care in Yorkshire'. Marriages brought more change of ownership through the Vansittart family to the Newcomens.

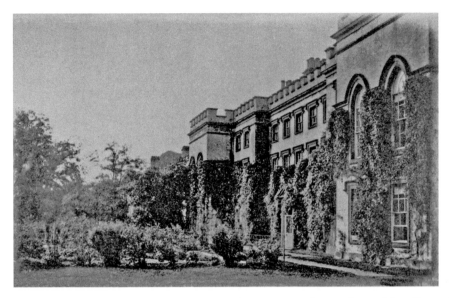

Kirkleatham Hall, once the home of the Turner family. (Courtesy of Beamish People's Collection)

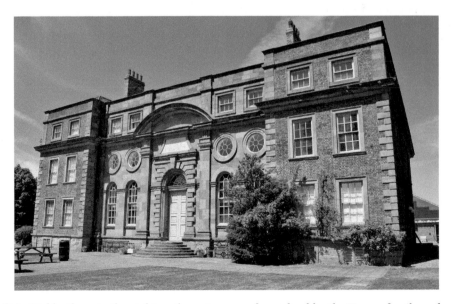

Built in Kirkleatham in the eighteenth century as a free school by the Turner family and now a museum.

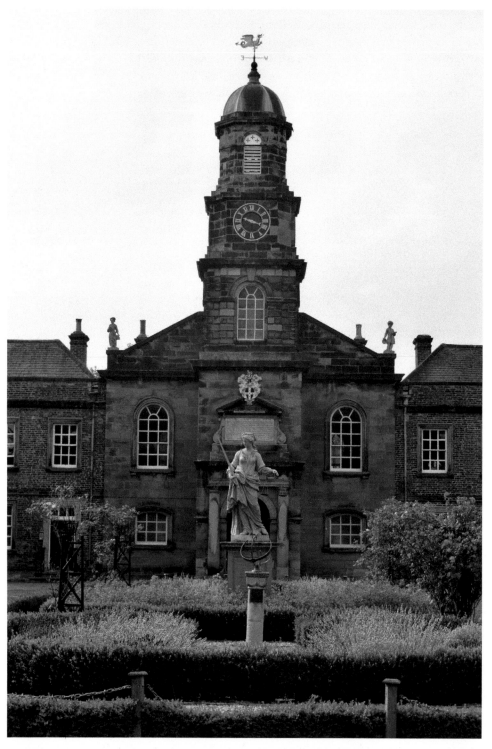

Funded by William Turner, the Kirkleatham hospital or almshouses provided homes for the poor of all ages and is now operated by a charity providing homes for older people.

At the entrance to the Kirkleatham hospital, fortifications stand ready to defend the estate!

DID YOU KNOW?
Kirkleatham Hall was built by the Turners in 1623. This grand hall survived until 1954 when it was demolished. There had been attempts to save the hall; in 1953 a short-lived Preservation Order was made by the Ministry of Housing, but the hall went the way of so many country houses. The auction of the contents brought interest as there were examples of Chippendale, Regency and Queen Anne furniture for sale.

Samuel Pepys was also aware of a family that became owners of land adjacent to Kirkleatham. Agnes de Brus inherited this land which included Redcar and Marske. She was married to Walter de Fauconberg, and the estate was passed down this family, through marriage and inheritance, to the Nevilles, Conyers and to John Atherton whose daughter married Sir William Pennyman. The Pennyman family have left their mark at Marske including the grand hall, but their influence did not endure, and the estate came into the hands of Anthony Lowther. Anthony was, for a time, an MP and he and his wife, Margaret, were part of London Society. They were often in the company of Samuel Pepys, who took a dislike to Margaret and wrote Anthony 'is too good for Pegg'. One evening in 1667 the Lowthers dined with Pepys, who was venomous about Margaret. He wrote

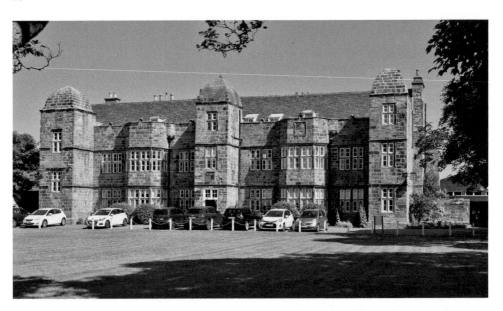

Marske Hall was built for William Pennyman in the seventeenth century. During the twentieth century it was used by the armed forces in two World Wars and was for a time a school, now a care home.

she 'has grown, either through pride or want of manners, a fool, having not a word to say almost all dinner; and, as a further mark of a beggarly, proud fool, hath a bracelet of diamonds and rubies about her wrist, and a sixpenny necklace about her neck, and not one good rag of clothes upon her back.'

In 1762, the estate was sold to Thomas Dundas, who was also in possession of two sugar plantations in the Caribbean: one in Dominica, the second in Grenada. The Grenada property had once belonged to a John Graham, who offered it for sale in the eighteenth century and advertised it with 239 acres, a house, sugar works, all slaves (supposedly around 140), with 32 head of cattle and 17 mules. The plantations were inherited by Lawrence Dundas, who owned them at the time slavery was outlawed in most of the British Empire. This came in 1833, after years of campaigning by abolitionists. To compensate the 'owners' for their loss, the government arranged compensation payments – Lawrence received his small share of the total payment of £20 million. By this time, he had been made the first Earl of Zetland, the ancient name of Shetland, where the family also had land. The last member of the family to live in Marske Hall was the Dowager Lady Zetland, who died in 1943.

This potted history has introduced some of those who are part of the heritage of the towns. It also explains the quirk of history that produced two distinct villages, Coatham and Redcar, which in later centuries, despite the two growing closer together, sometimes struggled to cooperate as they developed as resorts.

# 2. As the Gentlemen Go By

During the eighteenth century, the fishing hamlet of Saltburn harboured a nest of smugglers. The isolated stretch of beach was well suited for the smugglers who were avoiding the import duties levied on wine, brandy, gin, tobacco, tea, lace and silk. The increasing level of duties imposed by governments to provide funds for wars being fought in Europe and across the Atlantic made running contraband profitable. The smugglers' task was made easier when these conflicts took away troops and ships, which could otherwise have been used to patrol the British coast, leaving a somewhat ineffective response available to the authorities.

One attempt to curb the smuggling did bring results and gives an idea of the extent of the smugglers' trade. This came in 1784 when the duty on tea was radically reduced; the effect was seen in Stockton, which at that time was the major port in the area. Here, imports of tea were 11,993 lbs in 1780; however, by 1790, imports through Stockton had climbed to 89,088 lbs, an increase of some 18 tons. Tea had provided the smugglers with a considerable business, but they were able to turn to other profitable cargoes, leaving tea to legitimate shippers. Tobacco and snuff were such a cargo, and again, the result was recorded in Stockton. In 1780 there were 108,935 lbs imported and by 1790 it had fallen to 62,498 lbs.

DID YOU KNOW?
Smuggling was a two-way trade. To avoid the duties that were charged on the shipping of wool and sheep out of the country, smugglers were in league with farmers and merchants wanting to evade this tax. Those involved in this outbound trade were known as 'Owlers', whilst those smuggling goods into the country were 'Hoverers'.

Smuggling became big business and a network of local people were brought together to organise the trade. Finance had to be raised to pay for supplies. A good return could be had by those with the money to invest in a cargo, so perhaps wealthy local businessmen and gentry saw an opportunity. Somebody would be needed to travel abroad to negotiate with suppliers, agree deals and find shipping. When the contraband arrived off the coast, boats were needed to collect it and spirit it away to be concealed, perhaps buried in the sand, until it could be transported into the countryside and sold. There are stories of horses being left at night, saddled with their feet wrapped with sacking to dull the

sound of their hooves, ready for those moving goods inland. Women would move the contraband; some strapped a bladder full of spirits to their stomachs to pass as being pregnant. Not all contraband was shipped to order, and the smuggling bands needed to keep a watch out to sea for ships arriving offshore with cargo to trade.

The illicit business permeated throughout the area to become an important part of the local economy. In 1769, it was reported that 'accounts from Redcar, Saltburn and several places along the Yorkshire coast mention that smuggling trade was never carried to so great a height as present. The great number of people who attend at the coast (and seem to have no other employ but to convey off these goods) is almost incredible.'

DID YOU KNOW?
Rudyard Kipling told of the smuggling days in his poem 'A Smuggler's Song':
*Five and twenty ponies,*
*Trotting through the dark -*
*Brandy for the Parson, 'Baccy for the Clerk.*
*Them that asks no questions isn't told a lie -*
*Watch the wall my darling while the Gentlemen go by!*

Revenue officers were trying to stop the trade but were often overwhelmed and poorly resourced. One report commented on the situation, 'it does not appear possible to suppress this pernicious trade' unless more ships with suitably experienced captains were sent to patrol the coast. Patrolling the coast along to Huntcliffe was organised from Stockton. The official there with responsibility for the collection of duty was well aware that the smugglers were prospering and also voiced concern about resources. He asked for customs vessels that were well manned and commanded by a diligent officer. Patrols at sea were supplemented by land-based revenue officers. These people lived in the coastal towns and villages and were part of the community. This could bring temptation or coercion their way; some being aware of the smugglers' activities took payment or were intimidated into turning a blind eye. This does not seem to have been the case with John Terry, an officer based in Coatham. In 1780 he was involved in a battle with the crew of a smuggling ship. Customs officers, supported by ten soldiers, had arrived at the beach just as the crew finished unloading and had seized 200 tubs of geneva and forty bags of tea. These had been loaded onto carts ready to be taken to Stockton. The crew of the ship were not going to stand by and let this happen, and they went ashore armed with pistols and swords. They gave chase as far as Wilton, where they managed to take back one of the carts. On the way back to the coast, they encountered John Terry, who stood his ground and recaptured much of the contraband. On another occasion, the authorities did have some success: near Ormesby, two wagons loaded with potatoes were stopped by revenue men who searched the wagon and found geneva, brandy, tea and fine cloth hidden beneath the vegetables.

Gin cellars were used to store contraband. This one was uncovered during demolition of a house in Redcar. (Courtesy of Beamish People's Collection)

The smugglers' ships were not easily caught, and their captains were ready to fight off customs men. In 1773, a ship with fourteen carriage guns beside many swivel guns and around fifty stout men, several of whom had been on shore at Saltburn where they landed a great quantity of spirits, was leaving when one of the King's cutters arrived. It gave chase but seeing there could be considerable danger if an attempt was made to board, the captain thought it 'prudent to depart'. Customs men did not always act with such caution and captured a Dutch ship in 1780 as she was riding at anchor between Marske and Saltburn waiting for the return of a boat carrying eighty tubs of geneva towards the beach at Marske. A longboat was sent out, the spirit seized, and the smugglers' ship was taken. However, all but two men and a boy from the Dutch ship escaped in their boats to Saltburn. The escaping men could have found help in Saltburn, where the Ship Inn was a smugglers' headquarters. John Andrews was the landlord of the inn and, from there, organised much of the local trade and, like all

good smuggling stories, there were said to be tunnels leading to nearby cottages. He prospered and bought the nearby White House, which was reputed to have storage space under the stables where one of his horses was trained to kick any stranger trying to disturb its peace.

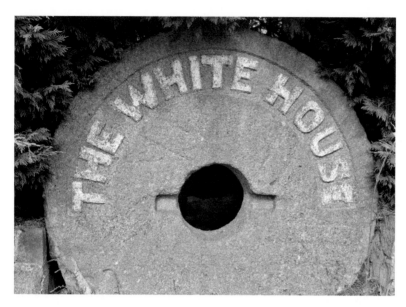

Standing above Saltburn is the White House, once the home of the head of a smuggling gang.

The smugglers' base at Saltburn was the Ship Inn.

John was in partnership with Thomas King, a brewer from Kirkleatham. They are said to have bought a ship, the *Morgan Rattler*, which was soon sought by revenue vessels. In 1790, it managed to escape two pursuing revenue cutters. The ship was well fitted to its task, being described as the fastest sailing lugger in the world. One report told of it being fitted with sixteen guns and crewed by 100 men. The hunt continued and in 1791 the Revenue's ship, the *Badger*, bore down on it off the Isle of Man. A battle followed, and most of the *Badger*'s crew were ordered to stay below deck because of the constant fire across the deck from the smugglers. Nevertheless, the captain and one of the crew were injured. The *Badger* was boarded and ransacked, the mast was taken down, as was much of the rigging, and the boarders left with sails, 4 guineas and a silver watch. The *Morgan Rattler* continued to Ireland to unload its contraband. The incident resulted in a reward of £1,100 being offered for the capture of the captain, mate, or any of the crew. This seems to have seen the ship taken to Dunkirk, where the captain was said to have had difficulty making the crew set sail as they feared being caught and tried as pirates. This was only a temporary setback, and the ship was soon back running goods along the Yorkshire coast.

John Andrews' son, another John, followed him into the trade and managed to have himself arrested and jailed at York after being unable to pay the fine of £100,000 imposed by the court. Meanwhile, his father was moving in different circles; he was given a commission in the local militia and became the first master of the Cleveland Hunt. Those involved in his appointment to the hunt included Henry Vansittart and Isaac Scarth, both landowners and respected people of the area. Given the illegality and sometimes violent nature of smuggling, how did he achieve these two personae? Could it be suggested that his activities were supported throughout the area and the trade that Andrews aided was to the benefit of many from all ranks of society? Later J. W. Ord, in his *History and Antiquities of Cleveland*, published in 1846, overlooked much of Andrew's past and described him as 'a gentleman from humble beginnings rose to great respectability in the neighbourhood'.

The end of the Napoleonic Wars in 1815 allowed vessels and men to be redeployed. Also, the coast guard service was strengthened, and the smugglers' work faltered. Locally, a row of coast guard cottages was built above Saltburn on Huntcliff. Smuggling was also referred to as free trade; ironically, it was the adoption of free trade by the government in the nineteenth century that resulted in duties being removed and the decline of smuggling.

As the nineteenth century progressed, Saltburn was described as no more than 'two or three humble looking cottages'. Both the legal and illegal trade from the beach was disappearing; nevertheless, the Ship Inn continued in business. In 1861, John Andrews' granddaughter Ann was living at the Ship Inn with her husband John Temple. She was divorced in 1865 – her husband cited Ann's adultery. She moved to be with her new husband near Darlington. As she was leaving, she would have been witnessing the building of a new town and the start of Saltburn being transformed into a fashionable resort. However, before looking at the development of Saltburn by the Sea, the story can move to Redcar to discover how a resort emerged there.

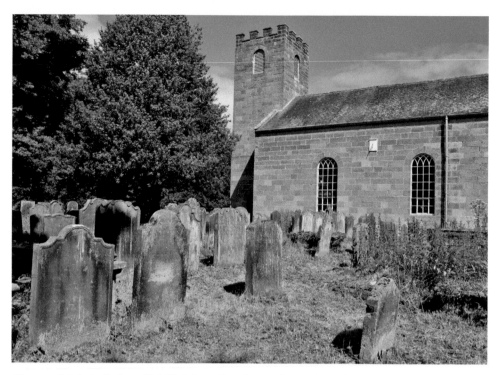

*Above and Below*: Skelton Old All Saints Church. Inside, Georgian box pews survive and in the churchyard is the grave of John Andrews.

# 3. Soon the Season Comes and Crowds Arrive

Redcar and Coatham were attracting visitors long before Saltburn was being developed as a resort. The two villages were close but were separated by a green and affiliated to different parishes: Coatham to Kirkleatham, and Redcar to Marske. By the late eighteenth century, accommodation was available for visitors – the Red Lion in Redcar was boasting rooms, stables and adequate housing for gentlemen's coaches. Along at Coatham, the proprietor of the Coatham Inn was thanking the 'nobility, gentry and others' for supporting the inn during 1807. This gives an idea of the types of people that could afford the luxury of a holiday. It was the custom of aristocrats, the gentry, merchants and wealthy traders who had the time and money to visit during the summer season. Whilst at the coast, the fashion was to take advantage of the health benefits that were said to come from sea bathing and drinking sea water. A refreshing dip in the sea could help with nervous disorders, stomach problems, gout, giddiness and cure many ailments. A trip to the seaside was often referred to as a visit to a health resort or watering place. However, turning to the sea for a cure was, as one wit noted, a useful aid for doctors whose healing powers in those days were limited.

Recommending that patients take the waters when no cure was available got them out of the way and avoided the disgrace of being accused of killing them.

DID YOU KNOW?
Along the coast Scarborough developed as a resort during the seventeenth century, and by the time Redcar and Coatham were emerging as holiday destinations it was well established as a fashionable health resort. Scarborough was catering for the well-to-do and was equipped to provide amusement for visitors with theatres, assembly rooms for dances and grand dinners, elegant shops and terraces with hotels and lodging houses. A day at Scarborough could involve a dip in the sea, followed by a horse or carriage ride along the beach, a visit to a library then dinner and dancing in the evening.

By the turn of the nineteenth century, Redcar and its neighbour Coatham provided few facilities and offered little amusement. A visitor in 1808 explained that Coatham was a street of around seventy houses whilst Redcar had around one hundred and sixty houses stretching along both sides of its single street. Both were troubled with sand being blown across the streets, blocking doorways, and making walking difficult. Visitors noted that

large mounds of sand were driven up by the wind and the tide and heard tales of people having to dig themselves out and clearing sand that covered windows. Those holidaying had to be content with the beach and sea during the day and cards at night. Excitement was provided by a boat trip across the Tees Estuary to Seaton, no doubt providing extra income for the local fishers, where tea could be taken.

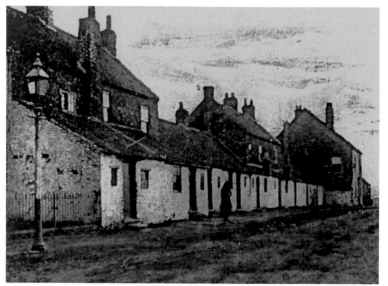

*Above*: The year 1698 is carved into the stonework of these houses in Coatham.

*Left*: Old Coatham. Houses facing the sea no doubt would have suffered from sand being driven from the beach. (Courtesy of Teesside Archives)

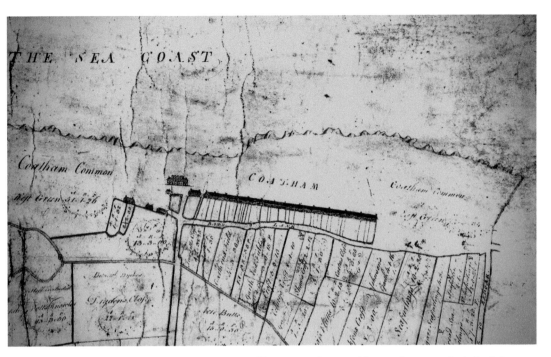

A map of Coatham in 1774 – just one street of houses. Is the grand house shown to the left of the street the New Inn? (Courtesy of North Yorkshire Record Office)

Providing hospitality for visitors from around 1760, this was Coatham's New Inn.

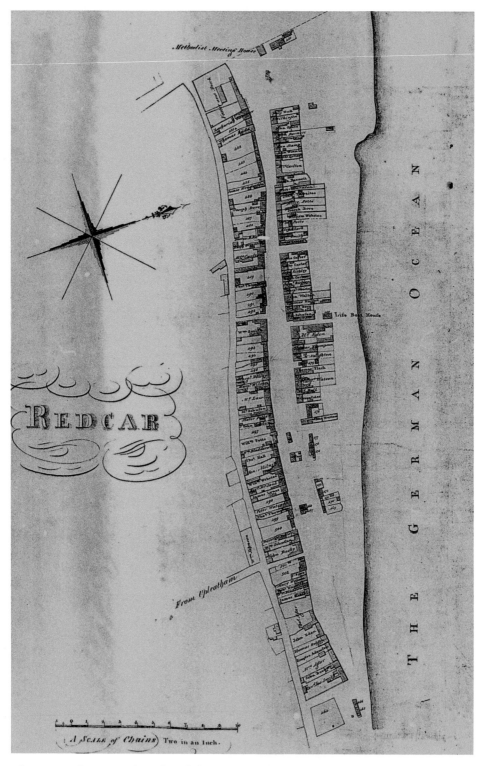

Redcar in 1815. (Courtesy of North Yorkshire Record Office)

Travelling to Redcar and Coatham could be tortuous and would merit staying in the resort for some time to recover before facing the return journey. Our visitor from 1808 took one week to travel the 184 miles from his home in the south, although to make the journey less arduous, he did take breaks to visit one or two towns on the way. He spent four weeks at Redcar, then took another week to return home. Redcar was in an isolated part of the country and getting there involved travelling along poorly maintained roads. The introduction of turnpike roads had improved the situation. In 1807, at the Tontine Inn, located on the turnpike road between Thirsk and Yarm, the arrival of the mail coach from the south coincided with the departure of the 6.30 a.m. coach, which called at Stokesley, Guisborough and Redcar. A coach returned in the afternoon at 4.30 to connect with coaches travelling to the north and south. As the resort grew, more coach services were introduced, particularly during the summer, the starting points suggesting that Redcar was attracting the wealthy from the farming districts in North Yorkshire. In 1817, a coach was running from Bedale to Redcar, calling at Northallerton to collect passengers. In 1826, a twice-weekly service left from the Crown in Thirsk. This departed at 11.00 a.m., reaching Stokesley at 2.00 p.m., Ormesby at 4.00 p.m. and Redcar at 6.00 p.m. These were slow and costly journeys, but before long, the railways would revolutionise travel. In 1844, the coach from Thirsk was timed to leave after the arrival of main line trains at the station, but by then it was acknowledged that it was fighting a losing battle with the railways.

Gradually, the two villages became recognised as fashionable resorts; facilities were developing, coffee houses and billiard rooms were opened, and balls were held in hotels. The type of accommodation that was offered was increasing and varied, ranging from hotels with provision to accommodate servants to houses that were available to be taken for the season. Some substantial houses were advertised for rent during the summer; one was offered with dining room, drawing room, housekeepers' room, nine bedrooms, stables and gardens. By 1822 there were a number of lodging houses; George Stamp was one proprietor who also could offer visitors pleasure boats and billiards. Hotel accommodation was provided at the Crown and Anchor, the Jolly Sailor, Red Lion, Ship and the White Swan.

The resorts were growing, but in 1835 there were plans afoot that could have completely changed the future of Redcar. The east coast was busy with shipping, but storms often made sailing along this coast dangerous, and there was no safe harbour that could provide shelter. The coast between Sunderland and Spurn Head was seen as a graveyard for ships. A new harbour was proposed at Redcar to offer a refuge for shipping, a naval base and a trading port. The plans showed a large port, big enough to take hundreds of merchant ships and provide a station for the navy. Redcar's fortunes would be transformed, and the nature and pace of development would radically change, bringing the trades and traders associated with a port. William Cubbit, the London-based civil engineer who had been involved in many canal projects and later worked on the designs for Middlesbrough Dock, reviewed the plans. His opinion was that it was a practical proposal and that the rock formation offshore of Redcar would simplify the construction of the foundations for the piers and harbour walls. The King, William IV, agreed to the use of his name, and Port William looked ready to proceed. However, to finance the port, ships passing would have to pay a levy based on the tonnage they were carrying, and this brought opposition,

particularly from owners in Newcastle and Sunderland. Their ships were constantly sailing down the east coast taking coal to London, and despite the refuge that would be provided, they opposed the scheme, and the bill to approve the work was withdrawn from Parliament. In 1839, another attempt was made to resurrect the idea; this time it would no doubt have become Port Victoria. Supporters pointed out that there had been 780 shipwrecks in the previous twelve years along the 100-mile stretch of the north-east coast. Opposition came again from those concerned about the levy, and in Stockton there was fear that the scheme would sound the death knell for the port there, particularly if the railway was extended to Redcar. This would mean ships would no longer have to wait for tides to make their way along the Tees, and goods could be unloaded and loaded at the entrance to the river without the need to navigate to the ports inland. Those opposing the scheme pointed out that many of the shipping disasters on the east coast were the result of negligence, incapacity, or drunkenness of ships' crews, which would not be changed by a port of refuge. There was also concern about the impact on trade in Whitby, and the town's member of parliament, along with the majority of other MPs, did not support the proposal. The scheme was defeated again, leaving Redcar to develop as a resort.

Whilst the plan for a harbour of refuge failed, it cannot be denied that there was a risk in sailing along this coast. Redcar's lifeboat, the *Zetland*, still renowned as the oldest surviving lifeboat, was called out many times. The crews faced danger every time they set

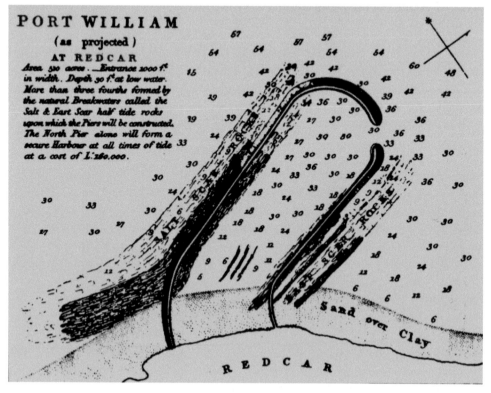

An outline of Port William proposed for Redcar.

out, and in 1836 whilst trying to rescue the crew of the *Caroline,* which had been driven into rocks, William Grey, who was at the helm of the lifeboat, was ready to throw a line to the ship when he was overwhelmed by the waves and drowned.

The railways brought a revolutionary improvement to the transport system; any forward-thinking resort would need to be linked to the national network. Naturally, Redcar residents realised that the town would benefit from a line; it would open the resort to more visitors. Improved transport would also open distant markets for the fishermen, whose catches could be taken quickly to the growing industrial towns. A connection to the rail network at Middlesbrough was proposed in 1841 but there were some difficulties to overcome before the construction could be started. The proposal was met with some concern in Middlesbrough, as there had been in Stockton with the earlier proposal for a port. During the 1830s, Middlesbrough had started to become a bustling town, benefiting from the coal trade through the docks there. In the town, there was unease as this could be concealing another plan to open a port that would damage trade in Middlesbrough. This fear was eventually allayed but finding backers willing to risk their money to finance the work was difficult. Eventually, the Stockton and Darlington Railway (S&DR) saw the potential and stepped in, agreeing to lease the line and guarantee the shareholders, who were to pay for the construction, a return of 5 per cent. The route did not involve the need for any major embankments or cuttings, and the 8-mile line was completed in eight months at a cost of £36,000. It opened in June 1846.

The first trains into Redcar arrived along the Redcar and Middlesbrough Railway to the sound of a cheering crowd and a band playing. A contemporary report described a scenic journey to Redcar, passing the Cleveland Hills on one side and the Tees Estuary on the other (not quite the same today!). There was no station at Redcar, and as part of the celebrations on the opening day, the foundation stone of a station was laid. The day ended with a grand dinner at the Red Lion Inn.

DID YOU KNOW?
*Locomotion,* the famous engine built at George and Robert Stephenson's works in Newcastle, was the first to run on the Stockton and Darlington Railway in 1825. Once more, it led the way and was the first engine to steam into Redcar.

The railway brought a radical change to the holiday trade; no longer would the seaside be the haunt of the gentry and the wealthy. The resort was opened up to more visitors and encouraged a significant boost to the development of Redcar. Day trips to the coast became practical and affordable. In 1847, a train of twenty-six coaches stopping at all stations from Richmond (Yorkshire) brought around 800 visitors for a day at the seaside. In the same year, hundreds of children from Sunday schools in Stockton were taken for a day excursion.

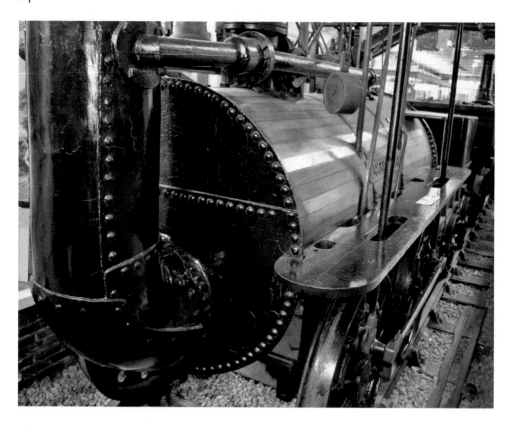

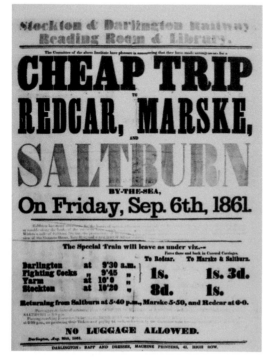

*Above*: In 1825 *Locomotion* was the first engine used on the Stockton and Darlington Railway and later the first to steam into Redcar.

*Left*: The transport revolution brought by the railways made the seaside accessible to many people. Excursions offered inexpensive days out. (Courtesy of the Centre for Local Studies, Darlington Library)

By the autumn of 1847, the station was almost complete. On the ground floor was a goods depot, and above was a refreshment lounge with grand views over the sea. Then disaster struck: a fire started. It was thought cinders had fallen from an open fire that workers had left burning when they had gone for a meal break. Fire ravaged the building; the roof collapsed and much of the interior was destroyed. There was no fire engine in the town and an attempt to quell the fire with a bucket chain was doomed to fail.

DID YOU KNOW?
Coal fires needed chimney sweeps and children were ideal for this work; they were employed to scramble up the brick-lined chimneys and wedge themselves to the sides whilst sweeping them clean. This was dangerous work and as early as 1788 it was made illegal to employ children as sweeps. These restrictions were ignored in 1847 by James Senior, a sweep from Middlesbrough who was caught compelling his son to climb and sweep a chimney in Redcar. He was fined £5.

The station was eventually completed but it was only used until 1861 when the railway line into Redcar needed to be relocated to allow the extension along the coast. The original route ran into the centre of the town but could not be continued through the High Street towards Saltburn. A new station was built and opened, the old track was lifted, and the first station became the Central Hall, a facility for visitors – in 1863, it had reading, smoking and refreshment rooms, with music during the evenings.

Redcar and Coatham were developing. The beach and the sea were the natural resources available, although for those not so sure about venturing into the North Sea, there was indoor bathing available. Visitor guides gave information about places of interest. One suggested a walk along the beach to the hamlet of Saltburn, which 'affords one the most delightful promenades'. Two miles away was Kirkleatham, with the grand hall, the William Turner Hospital and the free school in the village.

DID YOU KNOW?
Tom Brown was born in Kirkleatham, and he was the hero of the day at the Battle of Dettingen, fought against the French in 1742. This was also the final battle in which an English monarch led troops onto the battlefield. Tom suffered serious injuries, including having his nose sliced off as he battled to liberate the regiment's standard from enemy hands. George II rewarded Tom with a pension and a replacement nose made of silver. After leaving the army, Tom moved to Yarm.

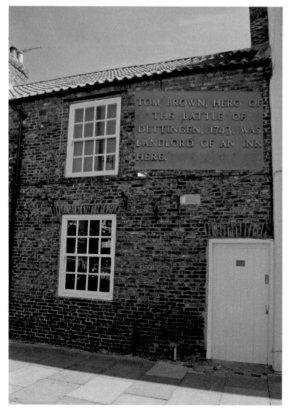

*Above*: In Kirkleatham local hero Tom Brown is remembered by a plaque beside an oak tree planted in his honour.

*Left*: The house in Yarm where Tom Brown lived after leaving the army.

From Kirkleatham, visitors could go on to Wilton, where another grand building was to be inspected. This was the castle built by Sir John Lowther in the early years of the century on the site of an ancient castle. To the east was Skelton and another castle, rebuilt in 1788 to replace its Norman predecessor. Alternatively, a day could be spent in Guisborough, with its shops and houses arranged along 'a spacious street … it may be described as one of the prettiest little towns in the north of England'. For the more active, a climb through the wooded hills to Eston Nab would bring glorious views of the countryside and the sea. There was also the look-out tower constructed to watch for French invaders during the Napoleonic Wars. Marton was a village worth visiting to see the birthplace of Captain Cook. Another recommended trip was to Middlesbrough to see the wonder of a hamlet of only twenty-five inhabitants in 1801 that had been transformed into a new industrial town.

Redcar, benefiting from the growing holiday trade, was expanding with hotels and lodging houses opening along the High Street. Not all recognised that Redcar was becoming a busy place, as the story of Nathaniel Hawthorne, an American novelist, tells. He was in Europe in 1859, and in July he arrived in London but found it was too busy and noisy to work there, so he decided to go to the bleak coast of Yorkshire and Redcar. Once there, he had to admit he was mistaken as he arrived in a town busy with holidaymakers. The town had come a long way since 1808, when our visitor told of resorts in 'their infancy'. Redcar alone had a population of 1,515, which had grown from the 431 recorded in 1801. Coatham had not expanded so rapidly, with 751 recorded in the 1861 census.

Whilst the resorts settled into their role, there was development that would change the fortunes of Redcar and Coatham. To uncover this there is a need to move to the story of Marske.

# 4. Old Town and a New Town

By the early nineteenth century, Marske was a collection of houses stretching out from the sea along the High Street. At the edge of the village was Marske Hall, built in the seventeenth century by William Pennyman, and at the other side of the main street was St Germain's Church. The churchyard is said to have attracted a Charles Dickens who visited to seek out the grave of Captain Cook's father. Cook's ageing, widowed father had gone to live in Redcar with his married daughter, Margaret Fleck, in 1771. He died in 1779, and as Redcar was served by the church at Marske, he was interned there. He had survived his son by a few weeks. However, he would not have known this as the news of the death of Captain Cook in Hawaii would not have reached Redcar. Unfortunately, Dickens would not have been successful as the grave was unmarked.

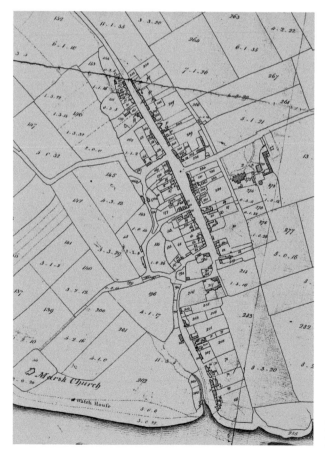

Marske in 1815. (Courtesy of North Yorkshire Record Office)

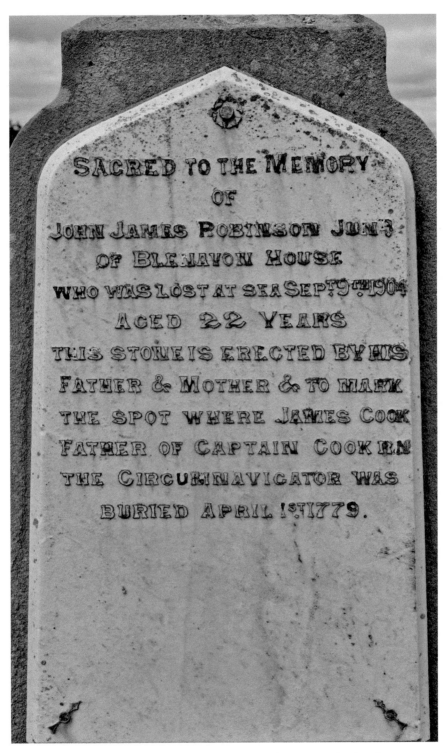

SACRED TO THE MEMORY
OF
JOHN JAMES ROBINSON JUN.
OF BLENAVON HOUSE
WHO WAS LOST AT SEA SEPT 9TH 1904
AGED 22 YEARS
THIS STONE IS ERECTED BY HIS
FATHER & MOTHER & TO MARK
THE SPOT WHERE JAMES COOK
FATHER OF CAPTAIN COOK RN
THE CIRCUMNAVIGATOR WAS
BURIED APRIL 1ST 1779.

Captain James Cook's father was buried in the graveyard of St Germain's Church in an unmarked grave. This memorial was erected later.

At the end of the High Street, cottages overlooking the sea were demolished (perhaps tunnels connecting the houses were uncovered, if tales from the days of smuggling were correct). This made way for Cliff House, a summer retreat built in the 1840s for Joseph Pease. Soon, the town would be even more aware of the Pease family and their businesses. Joseph was a member of the Quaker family from Darlington. Despite having the wealth to fund this grand house, his extravagance did not sit well with his father's Quaker values. He recorded in his diary that his son's extravagance was 'a measure I could not see it desirable on any account'.

DID YOU KNOW?
Joseph Pease was the great-grandson of Edward Pease, who had arrived in Darlington in the mid-eighteenth century to work in his uncle's textile business. Edward eventually took over the business and expanded it to become a major employer in the town. Joseph's father, another Edward, had played a significant role in the promotion and development of the Stockton and Darlington Railway (S&DR). Whilst maintaining an interest in the S&DR, the Pease business diversified; the mills continued to provide work in Darlington, Middlesbrough was developed by the Owners of the Middlesbrough Estate in which they held a major share, coal and ironstone mines were opened, all supported by the J. & J. W. Pease Bank.

Cliff House, Marske, built as a summer retreat for Joseph Pease, the Quaker businessman.

Marske had a population of 503 in 1801 and had changed little by the mid-century. The local farming community was served in the village by tailors, shoemakers, cartwrights, blacksmiths and bakers. Some visitors were attracted each year to this quiet retreat close to the beach and sea. Watching from the beach as ships sailed by out at sea could pass the time for visitors, but, as we have seen, the sea could be menacing, and storms brought danger to mariners. In March 1826, the *Esk*, a whaling ship, had left Whitby for the Arctic and had spent months in the waters around Greenland. Having to hunt the harpooned whale that was intent on escape was dangerous work. The crew would lower the boats and they would give chase; when surrounded by ice, they jumped from the boat to run over the ice, leaping from piece to piece to complete the kill. The *Esk* was so close to home, no doubt all hands looking forward to being back in Whitby, when a gale forced the ship towards the shore near Marske. The lifeboat was called out from Redcar, but the waves beat it back. There was little that could be done. Three sailors survived, washed ashore clinging to the wreckage.

DID YOU KNOW?
Along this part of the coast, the inlets or breaks in the cliffs are known as howles. Marske Church, Howle, is just below St Germain's Church. Along the coast towards Redcar is Bydale Howle.

Bydale Howle near Marske.

Marske, and indeed its neighbours, would soon face a momentous change, and to follow this story a trip to Middlesbrough is required. Here, Henry Bolckow and John Vaughan set up an iron forge in 1841. A few years later, they built blast furnaces to produce iron at Witton Park – this was at the far end of the original S&DR in South Durham. There was a plentiful supply of coal there to fire the furnaces and a supply of iron ore; however it was not a rich vein, and another source was needed. Iron ore had been found in the North York Moors around Grosmont, and was taken to Whitby and then shipped to Middlesbrough where it was loaded onto wagons to be hauled by locomotives to Witton Park. The pig iron produced in the blast furnaces was then taken back to Middlesbrough. This arrangement involved a great deal of movement, but all was to change when substantial deposits of iron ore were found in the Cleveland Hills.

DID YOU KNOW?
One story of the discovery of the ore tells how John Vaughan was in the Cleveland Hills shooting rabbits when he tripped and fell over a block of ironstone, and so the industrial history of the Tees Valley was revolutionised. This hides the work done by John Marley, a mining engineer employed by Bolckow and Vaughan, who helped to unearth the deposits. Ironstone had been found in Skinningrove and it was from this deposit that John Marley investigated the strata of the hills and concluded that the hills above Eston was the place to seek out another source.

Extracting the ore was soon started, first at Eston in 1850. Initially, the ore was quarried, then a drift mine with horizontal shafts was cut into the hills. Next, the mine in the hills above Marske at Upleatham was opened; the Derwent Iron Company operated this mine. The ore was then transported by a tramway that crossed the country to reach the Redcar and Middlesbrough railway near Coatham and then by rail on to Consett, where the company had blast furnaces.

Working in the mines was dangerous. Gunpowder was used to blast the stone and, once it loosened and the dust settled, the miner and his helper would start to use picks to break the rock and load it onto wagons. There was little safety equipment; protective headgear was usually a leather cap; moustaches filtered the dust; and string tied around trousers, just below the knee, kept rats at bay. Accidents were inevitable, as in August 1855 when Thomas Laskey, who was working in the Upleatham mine, fired gunpowder to bring down the ironstone and was starting to work with his pick when more stone fell and crushed him. He lived for six days before dying from his wounds. At the inquest held at the Dundas Arms in Marske, his death was recorded as accidental. Even away from the mine there was danger. One night in 1865, Marske was rocked by an explosion. It turned out a miner used a candle to light his way to bed, under which he was keeping his gunpowder dry. A lodger was killed, and the cottage destroyed.

Lord Zetland was the major landowner in the area, and this brought with it the right to the minerals beneath. In 1851, he leased the mining rights at Upleatham to the Derwent Iron Company and received a royalty for each ton of ironstone extracted. By 1857, the Derwent Iron Co. was in serious financial trouble. Its bankers, the Northumberland and District Bank, failed and closed its doors. The bank had supported the iron works with ever-increasing loans to the point where one million pounds was due. This amounted to half of the bank's deposits, and it was unlikely that any repayment of the loans would be made as the iron business was poorly run and making little money. This proportion of debt with one customer was too high and the bank was having difficulty meeting demands for cash from its depositors. It was left with little alternative but to close. The Pease and Partners mining business stepped in, negotiated with Lord Zetland and took over the lease at Upleatham.

Ironstone was taken by rail from the Upleatham mine. This was the route of the railway which connected to the main line from Redcar.

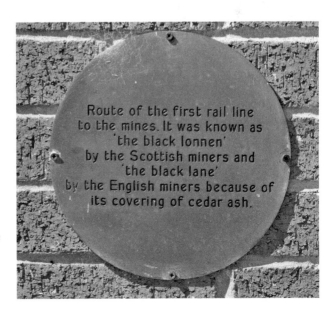

Route of the first rail line to the mines. It was known as 'the black lonnen' by the Scottish miners and 'the black lane' by the English miners because of its covering of cedar ash.

Work at the Upleatham mine brought families from across the country including those from Scotland, as this plaque along the route of the Upleatham railway recalls.

The Pease family still had a considerable interest in the S&DR and realised there was an opportunity to increase income from the iron ore trade by extending its line from Redcar towards Saltburn. From this, a short branch would link to the Upleatham mine. There was also a benefit for Marske, which would, at last, have a station. The village was also experiencing other effects of the mining boom; local folk took up work in the mine. When he was nineteen, Alexander Bell was a servant in the household of John Black, a farmer at Rye Hills. By 1861, he was an ironstone miner living in Cliff Terrace with his wife and two children. The Upleatham mine became an extensive operation, employing up to 1,000 and extracting 2,000 tons of ore a day. The work attracted people into the area, and some found lodgings in Marske, and builders were soon busy working on streets of new cottages. However, Maske could not cope with the growing number, so to remedy this in 1862, Pease started to build New Marske. It was described as a model village with comfortable houses, a reading room, cricket ground and school, and, in line with Quaker values, no public house.

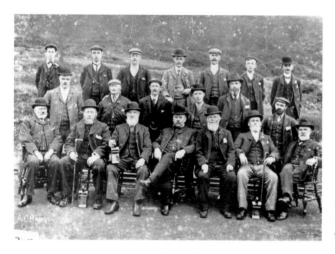

Upleatham miners in their Sunday best. (Courtesy of Teesside Archives)

New houses were built in Marske to meet demand from the influx of families attracted by work in Upleatham mine.

*Right above and below*: Joseph Pease had New Marske built to provide homes for workers at the Upleatham mine. The names of some of the streets show his influence. Charles Street, Arthur Terrace and Gurney Street are all named after his sons. Dale Street refers to David Dale who became a partner in the Pease mining business.

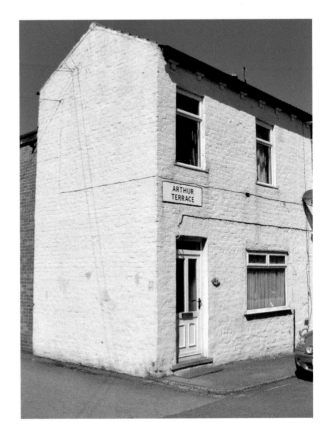

The mine was not immune to the ups and downs of the economy. During 1874, the price of pig iron fell from £6 per ton to £3.25. This was one example of the impact of the economic depression that was reverberating around the world at that time. Falling prices forced employers to search for savings and, of course, they looked at wages. The ironstone miners in Cleveland had been paid 1/5d per ton from which they had to pay their helpers who loaded the ore to wagons and for their gunpowder. A reduction of 2d per ton was imposed. The miners in Cleveland, when faced with this 121/2 per cent reduction, were determined to fight. Arbitration was offered and dismissed, so the mine owners prepared to close the mines and a strike followed. The Cleveland Miners' Association had been formed in 1872 with lodges at the local mines, and its leaders were concerned that the miners were not facing the reality that had been accepted by so many throughout the country – that wage rates were being slashed. There was also a National Association of Miners, and the representatives from this countrywide organisation also had grave doubts about any attempt to fight the wage reduction. On 13 May, at a gathering on the beach at Marske, they explained that this was the wrong time to strike but the hardliners among the men would not give in and the strike continued, bringing the comment in one newspaper that they were 'resolved upon ruin'. The impact was soon felt. Some of those who had been attracted to the area by the availability of employment moved away to find work elsewhere. Emigration was one option available for those wanting to leave the mines; shipping lines operating across the Atlantic from Liverpool advertised steerage-class tickets at reduced rates with onward transport inland to places where work could be found. Canada had opportunities but not for miners as, like New Zealand and Australia, there was little mining industry but there were opportunities in agriculture where many of the miners' roots were. Those left faced hardship. There were limited funds for strike pay in the coffers of the Cleveland Miners' Association and these were soon depleted. Some took to poaching. On the Turner lands, gamekeepers disturbed a band of around forty poachers and managed to have fourteen arrested. John Verrill, an ironstone miner from Redcar, was arrested for poaching and fined 20/6. He was no stranger to the courts; three years earlier, nineteen-year-old John and three other miners were in Kirkbymoorside on the day of the town's steeplechase. All four were arrested and charged with various thefts that had occurred throughout the town and sent to Northallerton prison to await trial. At his trial, John was accused of stealing a watch. The jury was told how the local policeman saw John and two other men approaching a haystack; however, when they saw the policeman, two ran off whilst John lay down and pretended to be asleep. The watch was found in the haystack, but the jury decided John and his accomplices were not guilty.

After six weeks, the strike ended and the reduction in wages was accepted. This was not the end, and in 1875 and 1876 further reductions were forced on the miners. A few years later, Lord Zetland made a sacrifice: he had been provided with an estimate that the royalties from the ore that was under his Upleatham Hall and grounds would yield some £20,000. He decided to allow mining to take place, with the consequence that the resulting subsidence damaged the hall, and in 1897 it had to be demolished.

**North=Riding OF Yorkshire.** **TO WIT.**

**Be it Remembered** that on the *Twenty seventh* day of *April* — in the year of our Lord One Thousand Eight Hundred and Seventy *five* — at Gisborough in the said North Riding, *John Verrill* — of *Redcar* — in the said Riding, *Miner* — is convicted before the undersigned two of her Majesty's Justices of the Peace for the said Riding, for that he the said *John Verrill* — within the space of Three Calendar Months now last past, to wit on the *Eighteenth* — day of *April instant* at the Township of *Kirkleatham* in the said Riding, unlawfully did commit a certain Trespass by entering and being in the day time of the same day upon a certain piece of Land belonging to *Arthur Henry Turner Newcomen Esquire* and in the occupation of *John Woodhouse.* — there in search or pursuit of Game, there without the License or consent of the owner of the land so trespassed upon, or of any person having the right of killing the game upon such land, or of any other person having any right to authorize the said *John Verrill* — to enter or be upon the said land for the purpose aforesaid, contrary to the statute in such case made, and we adjudge the said *John Verrill* — for h *is* said Offence to forfeit and pay the sum of

*Ten shillings* —

to be paid and applied according to Law, and also to pay to *George Charlton* — (the Informer) the sum of *Ten shillings and sixpence* — for h *is* costs in this behalf; ~~and if the said several Sums be not paid forthwith,~~

we adjudge the said
to be imprisoned in the House of Correction, at Northallerton; in the said Riding ₂
for the space of

unless the said several sums, and the costs and charges of conveying the said ~~to the said House of Correction shall be sooner~~ paid.

**Given** under our Hands and Seals the day and year first above mentioned at Gisborough aforesaid.

*J. T. Wharton*
*John G. Swan*

John Verrill, an ironstone miner, was caught poaching and fined, with costs 20/6d. (Courtesy of North Yorkshire Record Office)

# 5. Industry and Zeppelins Move on a Holiday Resort

The opening of the ironstone mines at Eston and Upleatham and the substantial quantity of iron ore that could be produced naturally led to the construction of blast furnaces and other iron works. The first came in 1852, when Bolckow and Vaughan built the Eston Iron Works. More followed, and the River Tees was soon flowing past belching furnaces from Stockton to South Bank. The spreading industry eventually approached within a mile or so of Coatham; this was in 1872 when the Dowey Co. started building two blast furnaces. At the same time, Robson, Maynard and Co. were also building furnaces to process ore mined on the Kirkleatham estate. The mine was towards the southern edge of the estate at Dundsdale, and a railway 5 miles long had to be built to carry the ore to the Robson, Maynard furnaces. A new partner was introduced, and the business became Walker, Maynard and Co., and operations were expanded to take over the running of the mine and pay royalties to the Newcomens, who were the owners of the Kirkleatham estate.

The growing industry near Coatham brought demand for more housing, and Newcomen land was being offered for sale at Coatham in 1872 with 'a portion specially set apart for workmen's cottages within a five-minute walk of the blast furnaces at Tod Point'. This became the new settlement of Warrenby. In June 1895, the community was brought together in grief when boilers exploded at the Maynard and Walker works; scalding water and flying shards of molten metal killed and injured many. Some of the injured survived for a time in hospital, but the eventual death toll was twelve. At the inquest, an engineer who had examined the destroyed boilers reported that nearly all of them had been repaired and patched, but that the repairs had not given way. The coroner concluded that the explosion had been caused by the boilers overheating, but why this had happened was not known as the boilers were properly cared for. It was decided that nobody was responsible and a verdict of accidental death was recorded. A Board of Trade inquiry was not so dismissive. It highlighted deficiencies in the boilers which the firm had known about for some time. The welded and riveted seams of the cylindrical boilers, which were 66 feet long, had ripped open. An engineer from the insurance company had warned of the danger and had suggested cutting them in half or replacing them with equipment of a better design. The inquiry did not find any employees at fault but held the company responsible for failing to react when they had knowledge of the danger. Costs of £250 were awarded against the company.

The growing industry around the Tees brought more shipping. The Tees Conservancy Commission started a scheme of improvements to the river between Middlesbrough and the open sea with dredging and improvement of the retaining walls to define the riverbanks. The Commissioners decided breakwaters at the mouth of the Tees would provide the refuge that had been proposed earlier in the century. The South Gare breakwater was started in 1861. The foundation stone was eventually laid in 1863 and by

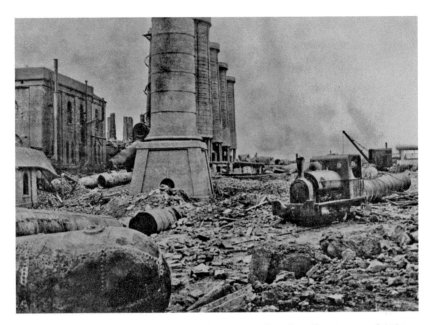

The devastation caused by the explosion at the Maynard and Walker ironworks. (Courtesy of Teesside Archives)

Warrenby village was developed in the late nineteenth century but by the 1970s was readied for demolition. One reminder of the village is this shell of St Mary's Church.

then it was already over a mile long. The work was eventually completed in 1888. Even the construction work was hampered by storms. In 1862 the railway that brought materials to the works and had been extended onto the breakwater was washed away.

DID YOU KNOW?
A way was found to keep the construction cost of the breakwater to a manageable level. This was done by using slag from the iron furnaces that were operating along the river. The iron masters had a problem disposing of the huge amounts of slag they produced and were happy to pay 2d per ton to have this taken away. The scheme was completed in 1888, by which time 25 million tons of slag had been encased within the concrete walls.

Despite the encroachment of the new industry, Redcar and Coatham were still attractive to those who could get away from the industrial towns with their chimneys belching out steam, flames and sulphur. There was an influx of professional people and managers into Coatham, including some of the local iron masters. The railway was providing work for porters, engine drivers, clerks and the stationmaster, whilst the holiday trade continued to give opportunities for lodging house proprietors and hoteliers.

In 1871 Coatham was the home of Jeremiah Head, an engineer who had worked for Robert Stephenson & Co. in Newcastle and later had built engines to power textile mills

In the 1850s Redcar faced an outbreak of cholera centred around poor housing in Fishermen's Square. The area was demolished and new houses built, including this one with a look-out post to watch for fishing boats in danger.

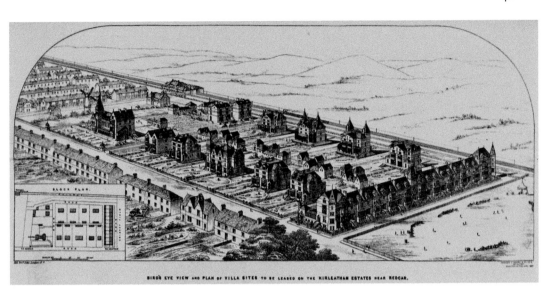

BIRDS EYE VIEW AND PLAN OF VILLA SITES TO BE LEASED ON THE KIRLEATHAM ESTATES NEAR REDCAR.

*Above*: A plan of the development of Coatham from 1867. (Courtesy of North Yorkshire Record Office)

*Right*: Traces of this 1867 plan can still be seen. Across the cricket ground in Coatham is Nelson Terrace.

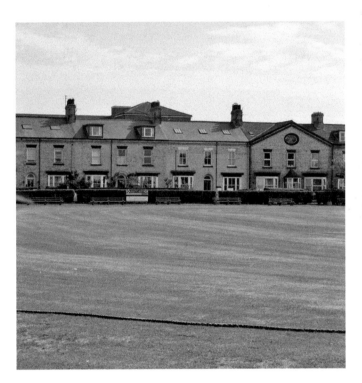

in Darlington and paper mills in Shotley Bridge. By the time he moved to Coatham, he was a partner in the firm of Fox Head and Co., which had opened the Newport Rolling Mills in Middlesbrough in 1863. Also in Coatham was Theodore Fox, the co-founder of the rolling mills, although he later found Saltburn a better place to live. Thomas Backhouse, a shipbuilder from Middlesbrough, was living in Coatham Villas. Red Barnes was the

home of Sir Thomas Bell, an iron master living with his wife, daughter Gertrude, son Maurice and six servants. Thomas had followed his father into the Port Clarence Iron Works of Bell Brothers. This firm had started in business with iron works in Newcastle, then in 1853 moved south to open a new facility at Port Clarence, on the north banks of the Tees, where furnaces processed the ironstone brought from mines they operated near Skelton. Gertrude led an adventurous life after studying Modern History at Oxford; during the First World war she was recruited by British Intelligence.

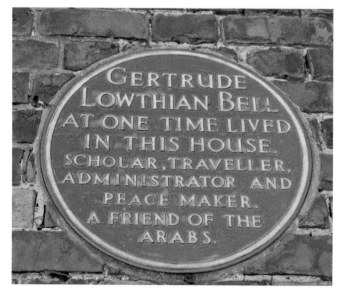

*Above*: Red Barnes built for Sir Thomas Bell.

*Left*: Thomas Bell's daughter, Gertrude, spent much of her life in the Middle East. One biography titled her the 'Queen of the Desert'.

DID YOU KNOW?
Red Barnes was built for Thomas Bell to a design by Phillip Webb, the architect who brought new designs to country houses and is regarded as a forerunner of the Arts and Crafts movement in the latter decades of the nineteenth century. Webb's other 'Red' building, the Red House in Bexleyheath, is now looked after by the National Trust.

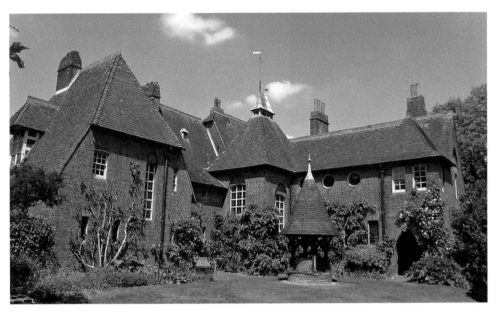

Phillip Webb's Red House in London. (Ethan Doyle Smith CC-BY-SA-3.0)

Gertrude Bell's stepmother, Florence, was a writer. In her book *At the Works* published in 1907, she explained that the iron trades were a success story and were held as contributing much to the nation's prosperity. However, she wanted to 'put this under the microscope' and recount how those working to produce this prosperity fared in the rows of terraced two-up, two-down houses in Middlesbrough. These people were not prospering; they found ways to survive and balance, or almost balance, their budget. She described the different ways families had of managing their income to pay rent, feed, heat and clothe their families. They could fall back on the tallyman, who would take weekly payments for goods he supplied, and the pawnbroker, but there was the constant fear of disaster that could follow if illness struck, and income stopped. Overcrowding was noticeable and she found a family of eleven with some having to sleep, dress, cook and eat in the kitchen. Leisure time was a potential source of disorder, especially on Sunday when libraries, theatres, working men's clubs and museums were closed leaving little else than the pubs open.

Coatham was catching up with its larger neighbour and both towns were growing closer to one another – one observer noted it was difficult to know where one begins and the other ends. The two towns would eventually amalgamate, but in the meantime, there were instances when resistance to cooperation between the two surfaced and produced wasteful competition. Much of the local administration was undertaken by a Board of Health; Redcar had its own, while Coatham was part of Kirkleatham, which in turn was looked after by Guisborough. It was recognised that Coatham was in need of a Board that was aligned with local needs. A government inquiry suggested that the two resorts should merge. However, Coatham residents did not want this and formed their own Board of Health in 1877.

The story of the two piers highlights again how antagonism between the two produced a poor outcome. The hoteliers and business owners in each town wanted facilities that would improve their resorts and encourage visitors and acted to achieve this without listening to the opinions of those who saw the pitfalls of such single-mindedness.

A pier for Redcar had been approved by the Board of Trade in 1866 but there was little progress until 1868 when it was announced that a pier was to be built at Coatham. The folk of Redcar reacted, resurrecting their plan, and arguments between the two rival groups followed. Both wanted a pier, no doubt encouraged by the news from Saltburn that the newly opened pier there had attracted 50,000 paying visitors in the first season. However, many warned that two piers so close together would lead to financial disaster and argued for unity and the triumph of common sense over civic pride. Funding to pay for the construction came from the issue of shares, and shareholders expected a return on their investment. Dividing the potential income from visitors between the two could reduce or eliminate any return. The Coatham pier was estimated to cost £7,000 and the Redcar £6,000. The Board of Trade became involved in an advisory capacity and supported the Coatham pier as it was to be built at the end of a direct route from the railway station, whilst the other was to be on a remoter site to the east. The clash continued and legal action was threatened at one point by the Coatham group to stop Redcar's application to renew the original approval, which was about to become time expired.

DID YOU KNOW?

By the later part of the nineteenth century, any self-respecting resort would have a pier for visitors to promenade along and take the sea air. However, they also served another purpose by providing a landing stage used to tie up ships that brought visitors or offered day trips along the coast. Those without piers saw passengers being transferred from ship to shore in rowing boats, then for the last few feet, splashing through the shallow water to the beach. An inconvenient performance, especially for the ladies who required carrying.

Eventually, both piers were built; Redcar opened in 1873 and Coatham two years later. Of course, the sea took its toll on the piers. Even before the Coatham pier was opened, it was ripped apart and left in three sections. This happened during a storm in 1874, which forced two out-of-control ships into the pier, smashing the columns and decking. First came the *Griffin*, quickly followed by the *Currunbuos*. This was not the end. In 1898, the wreck of the *Birger* damaged the pier, cutting through a long section. The *Birger* had set sail from the Mediterranean coast carrying salt bound for Finland. As the ship approached Norway, a severe storm blew it off course and forced it south. On 19 of October, it was spotted near Scarborough flying a distress signal. As the Scarborough lifeboat prepared to launch, the *Birger* moved north. At Whitby it tried to enter the harbour but could not manoeuvre through the high seas. By the afternoon it was off Saltburn, taking on water, its sails in tatters and the distress flag still flying. The ship was wrecked, masts fell, and the crew were left to try and reach the shore. The lifeboat was launched, but the sea was so fierce it could not reach the wreck. Those watching on Coatham pier saw three men had managed to reach the pier and were clinging to the legs. Ropes were thrown down, one man was hauled up, the other two could not hold on and were lost. Another man, clinging to a fragment of wreckage, managed to make it towards the beach and was pulled to safety. These were the only two survivors of the crew of fourteen. A few days later, bodies were washed up at Saltburn and taken to the mortuary there.

The Redcar pier fared no better. Poor navigation by the captain of the steam ship *Cochrane* brought it aground on rocks near Redcar. It managed to re-float at high tide but had taken on so much water that it could not be steered, so the captain decided to beach the ship. Unfortunately, he was unable to prevent the ship from crashing into the pier in the process. This was not the end. Fire damaged the pier in 1898, wrecking the pier head

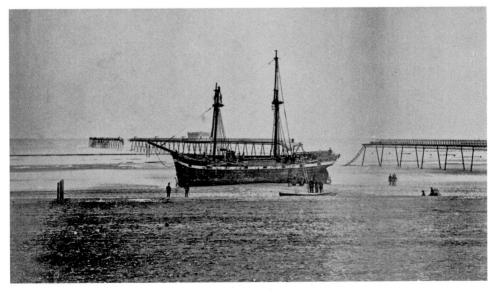

The *Griffin* beached near the extensively damaged Coatham Pier. (Courtesy Beamish People's Collection)

*Left and below*: Most of the crew of the wrecked *Birger* perished and were buried in Coatham's Christ Church.

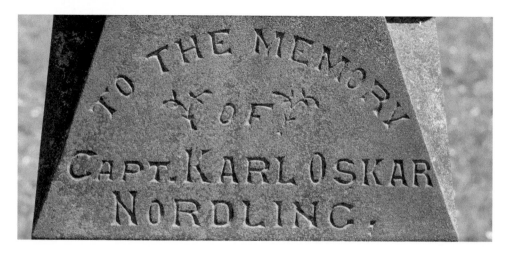

where a band had been giving daily concerts. Repairs and maintenance had forced it to be mortgaged, and the managers of the debt-ridden pier were having difficulty funding refurbishment. The piers have gone. Despite attempts to keep them alive, the attraction had died.

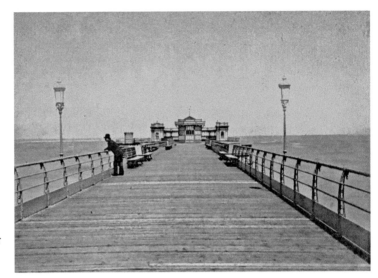

A quiet time at Redcar Pier. (Courtesy of Teesside Archives)

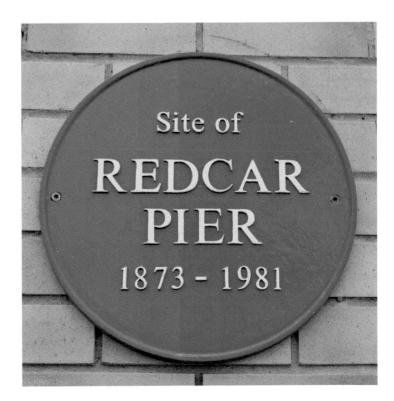

Redcar Pier had a troubled history. The sea and fires brought disasters, a mine exploded by the pier during the Second World War, and storms caused damage. By 1981 what remained was demolished.

By the turn of the twentieth century, Redcar and Coatham had been brought together into one council area. A resort system had also been created along this coast with areas that catered for all tastes. Much had changed in the surrounding area with the advancing of industry; the rail journey to the coast had certainly changed from the early accounts. One visitor told of the 'very striking appearance of the iron smelting country as we travel by railway after dark to Redcar'. The 'glare of successive furnaces accompanied by clouds of smoke alternates with the gloom that comes between. Works are now within four miles of Redcar'. Travelling in daylight brought a different view: 'you have to plunge through a frightful district of squalid towns, dirty rivers and endless iron works to emerge into this pure, white, sweet aired place'.

However, the country was soon plunged into war, and Redcar and Marske were taken over by the military. A military base had been established in the late nineteenth century at the South Gare, from where mines had been laid to protect the entrance to the Tees. An airfield was set up to train pilots near the racecourse which was taken over for an army camp. Other buildings were requisitioned by the military throughout the town, and Red Barns like the Convalescent Home were turned into hospitals. Whilst fighting was overseas there were considerable threats to those left at home. In December 1914, German battleships steamed along the coast bombarding Scarborough, Whitby and Hartlepool; however, they did not focus their guns along the coast around Redcar. There was also the growing threat of Zeppelin raids. These motorised balloons were developed by Count Ferdinand von Zeppelin in Germany from the 1890s, and eventually the design was

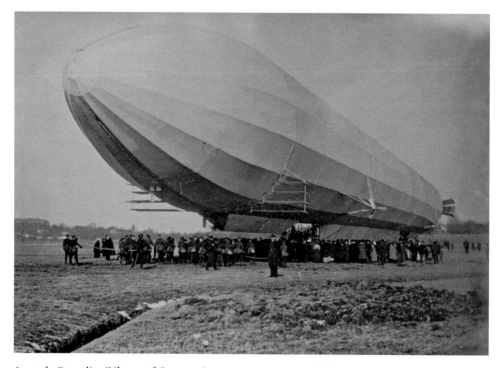

An early Zeppelin. (Library of Congress)

refined until they became capable of long-distance flights. They were hundreds of feet long, cigar-shaped balloons filled with gas, and strung below were the driving engines, steering mechanisms and gondolas for pilots and bombs. Initially, they were used for reconnaissance and for bombing raids in mainland Europe, but by 1915, they were crossing to England and Scotland on bombing raids. Redcar was targeted, lives were lost and there was substantial damage to property. In 1916, reports were telling of a 780-foot-long airship being developed that could carry 5-ton bombs across the sea at 75 mph. Aircraft were sent up to attack them and, to provide early warning of the approach, sound mirrors were built along the east coast. These concrete structures had mirrors 10 feet in diameter that collected the sound of the Zeppelin motors, a trumpet device concentrated the sound and the soldier operating the mirror attached a stethoscope to the movable trumpet to determine the direction that the attacking aircraft should fly. A mirror was built at Redcar, and there were others along the north-east coast at Sunderland, Hartlepool and Boulby.

The concrete housing for Redcar's Sound Mirror and the plaque detailing its purpose.

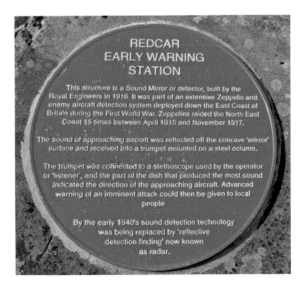

Did You Know?
**Stockton on Tees Y Station**
There was a more sophisticated method of intercepting airship movements being developed in a Royal Navy wireless station in Stockton. It was originally used to monitor the signals between the ships in the fleet, but with the outbreak of war the attention of the staff in the station was diverted to listening to enemy communications. Vital information was received about ship movements and the approach of Zeppelins on bombing raids. The station was able to intercept messages from German Naval Airship Divisional HQ as well as German Naval Headquarters at Kiel.

Marske became a military base, and huts to house recruits were built on the site of what is now Baydale School. Digging trenches was part of the training and soon the headland was criss-crossed with these. The development of aircrafts brought a new battle ground, and training facilities for pilots became vital. In 1917 an aerodrome was opened on fields at Marske. The Stray had targets erected along the cliffs to provide gunnery practice for the pilots. Guard posts were at each end; the one at the Redcar end of the Stray later became the café. Some flying aces were brought to Marske to help with instruction, among them Arthur Ray Brown, the pilot who shot down Germany's Red

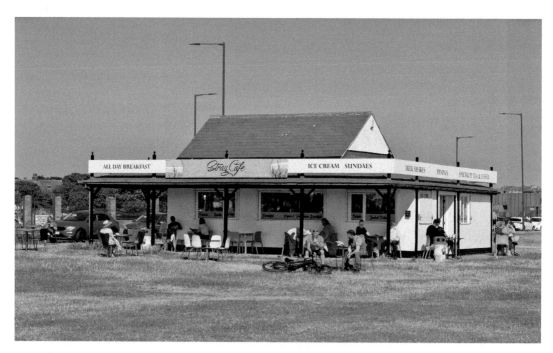

The Stray Café at Redcar. This was a guard post during the First World War.

Barron – Manfred Von Richthofen – who became famed as Germany's ace fighter pilot credited with shooting down eighty allied aircraft. As his reputation grew, he took to having his aeroplanes painted red, earning him the Red Barron title. Also stationed at Marske for a time was Lieutenant W. E. Johns who would pilot bombing missions over Germany and in 1930 became an author writing many books about the adventures of the fighter pilot Biggles.

*Above and below*: The aerodrome at Marske was operational between 1917 and 1920 and much of the site has been used for housing. The street names are all associated with aircraft. Blackburn Grove remembers early flights along the beach at Marske by Robert Blackburn while others don't relate directly to the early days – Halifax and Lysander Closes both relate to aircraft of the Second World War.

W. E. Johns, author of the Biggles books.

# 6. An Explosive New Town

One afternoon in the summer of 1859, Henry Pease was staying at Cliff House, his brother's villa in Marske, when he disappeared. He returned late and explained to his wife that he had walked along to Saltburn where a few fishermen's cottages met the sea and 'seated on the hill-side he had seen, in a sort of prophetic vision, on the cliff before him a town rise'. This is a romantic version of the conception of a new town which hides the hard business motives for its development. The family's investment at Middlesbrough, through their holding in the Owners of the Middlesbrough Estate, had been attractive and this could be another opportunity. There was also the potential to increase revenue from passenger services on the railway being extended to serve the ironstone mines beyond Redcar.

The land at Saltburn belonged to Lord Zetland and Henry had to find out if he would sell. G. D. Trotter, Lord Zetland's land agent, was approached. He made enquiries and wrote 'there is every reason to suppose that Lord Zetland will be desirous to afford every facility in his power to promote the object you mention at Saltburn'. Henry was able to gather a group of investors who were known to him from other ventures such as the Stockton

This was once the Zetland Estate Office in Marske.

and Darlington Railway (S&DR), the development of Middlesbrough and industrial projects to join him in investing in the Saltburn Improvement Company. These included Henry's brother John and his nephew, Joseph Whitwell Pease. There was Isaac Wilson, who had arrived in Middlesbrough in the 1840s to work in the Middlesbrough Pottery. He went on to become a maintenance manager for the S&DR, and later formed, with Edgar Gilkes, the engineering works of Gilkes, Wilson & Co. Also among the stakeholders were Thomas MacKay, the secretary of the S&DR, and Arthur Kitching, whose fortunes had changed when his ironmongers shop in Darlington supplied some nails to the S&DR, and from there the business had grown to build locomotives and carriages. A few years earlier, Alfred Kitching and Thomas MacKay had been amongst those who, along with Henry Pease, had formed the South Durham Iron Works in Darlington. With this support Henry was able to develop his dream and create a new resort. Land was bought from Lord Zetland, initially only 10 acres, but the option for more was agreed. However, the need for more land would suggest the project was becoming successful, and Lord Zetland would also benefit from the price per acre increasing. The Saltburn Improvement Company's land sale records show that £30,385 was spent buying land. The first row of houses was started in 1861 at Alpha Place, followed by the streets named after gems. Was this to become the jewel of the north?

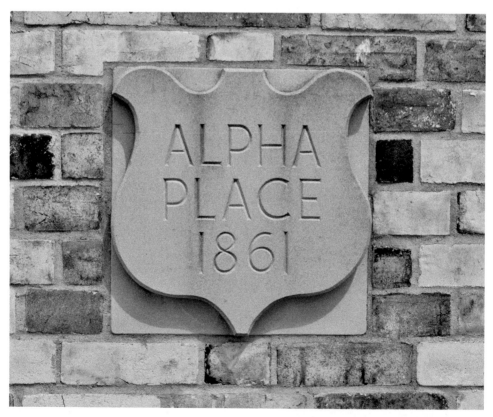

The site of Alpha Place where the first houses in the development of Saltburn were built.

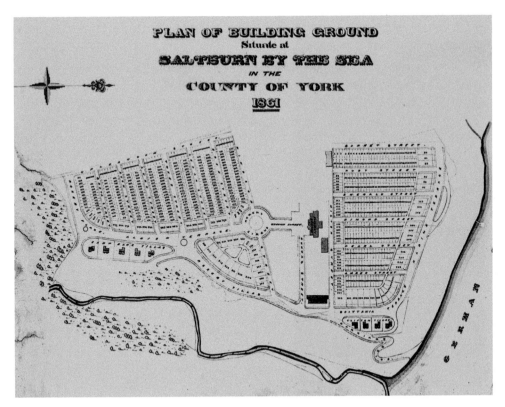

Outline plans for Saltburn dating from 1861. (Courtesy of North Yorkshire Record Office)

**DID YOU KNOW?**
Ruby Street was the home and office of Joseph Toyn. In 1876 he was elected as agent of the Cleveland Miners' Association. He, like many of the miners in Cleveland, had arrived from Lincolnshire where he, it is said, started work at the age of seven earning 3d for his twelve hours spent daily chasing crows from a farmer's field. He started work in the ironstone mines as a horse driver before moving on to become a miner. He took over the union leadership at a difficult time: the strike the year before had failed and Joseph Shepherd, who had been one of the union's founders, was dismissed for drunkenness and neglect of his duties as union secretary.

Meanwhile, the railway arrived. The first passenger service to Saltburn started in August 1861 and, as there was no accommodation yet for visitors, it was promoted as an opportunity for those on holiday in Redcar to take the fifteen-minute journey to survey the splendid views of coast and country from the lofty cliffs. This seems to have worked as 6,000 people used the route in the first six weeks of operation. Of course, more passengers would use the railway if hotels were built, and here was another opportunity for the S&DR.

The grand Zetland Hotel was designed by William Peachey, an architect working for the railway who was also responsible for the Royal Station Hotel in York. When construction of the hotel was announced at a meeting of the railway's shareholders, not all thought this was a good move. One shareholder, a man from Guisborough, complained it was a 'very bad speculation ... it is a nasty, bleak, cold place and the sand is hard'. Another suggested that intoxicating liquor should not be sold in the hotel, but despite this and the Quaker representation amongst the railway ownership and their support of temperance, there was little backing for this idea and commercial necessity triumphed. There was luxury and comfort for visitors in the large coffee and dining rooms, the spacious reading room, billiard room and smoking room.

Joseph Toyn, president of the Cleveland Miners' Association, once had his office and home in Saltburn's Ruby Street.

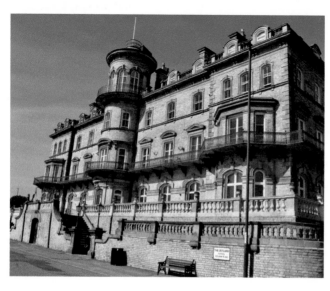

The 'immense' Zetland Hotel was opened in 1863, although one shareholder in the Stockton and Darlington Railway questioned spending £8,000 on the building.

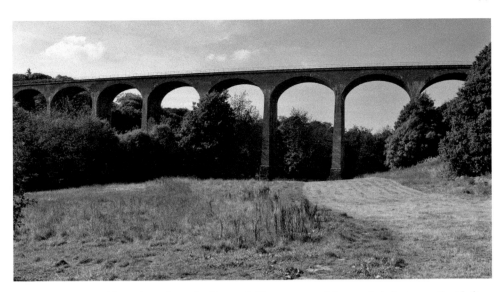

Opened in 1872 and branching from the line to Saltburn across this grand viaduct over the Skelton Beck, the railway was extended towards Skelton and the ironstone mines.

The Saltburn Improvement Company controlled the authorisation of building plans to ensure the resort was not spoilt. There was a requirement that the white bricks produced by the Pease brickworks at Crook be used on the façade of buildings. Only the fronts of houses or shops could face the street, while warehouses and workshops had to be well away from the street frontage. Among the trades prohibited were soap boilers, tripe men, curriers, candle makers, fell mongers and blacksmiths. All streets were to be properly paved with flagged stones.

Visitors were catered for in the shops along the canopied streets including confectioners, a silk mercer and a jet merchant, dealing in this fashionable jewellery. During the nineteenth century, rings, bracelets and necklaces made from this black gem became popular, with demand increasing on the death of a public figure – Queen Victoria's wearing of jet after the death of Prince Albert provided a major boost. The valley gardens had been set out, overlooked by the classical entrance portico brought from the station at Barnard Castle. Hidden in a quiet spot was a spring which provided the spa water that so many resorts boasted. Taking the waters was, like sea bathing, promoted as having health benefits. A resort that could advertise mineral waters increased the chances of attracting visitors. A source was found at Saltburn, and an analysis of the water produced in 1864 revealed that it had the same qualities as the famous spa water at Harrogate. Not surprisingly, in this district there was a trace of iron. This was advertised as a key component in the water along with chloride of sodium, which would stimulate the gastric juices and so make the digestion of the iron into the 'general system of circulation' and help with any condition involving 'poverty of the blood'. Leading from the gardens, according to one visitor, the walk led to 'romantic woods as far as Skelton and its castle. . . . 'the birthplace of a lofty, illustrious line of nobles and the ancient cradle and nursery of warriors, princes and kings . . . and above all Robert de Brus'.

The water from the spa well in the valley gardens used to flow from this fountain.

Did You Know?

**A Hell Fire Club at Skelton?**

During the eighteenth century, clubs appeared around the country, organised by wealthy men seeking to shock with their pursuit of hedonistic pleasure. The most notorious was the Hell Fire Club of Sir Francis Dashwood at Medmenham Abbey. By this time, Skelton Castle was the home of John Hall Stephenson, who nicknamed it the Crazy Castle. From there, John ran the Demoniacs Club and brought together a group of gentry and clergy for days spent playing sports outdoors and drinking and talking by night. Members included local landowners, army officers and Laurence Sterne, the author of the bawdy *The Life and Times of Tristram Shandy, Gentleman*.

New houses were springing up around the town with some available to rent for the holiday season. Henry Pease, seeing his dream come true, sought a house there as a summer retreat and in 1865 he was offered a house in Britannia Terrace for £1,650. His wife recalled they spent three or four weeks in Saltburn almost every summer, forming a very happy part of the children's holidays with 'the fine sands for driving or walking, the boating and fishing and listening to bands in the gardens'.

*Above*: The Alexandra Hotel provided competition for the Zetland Hotel, although both are now converted to apartments.

*Right*: A house in Britannia Terrace became a summer retreat for Henry Pease and his family.

Competition for the Zetland Hotel appeared in 1867 when the Alexandra was built for John Anderson, an engineer on the S&DR. However, apart from the gardens and the beach there was little to amuse visitors, and from his hotel, Anderson took the lead in providing another attraction. A pier had been suggested in the early days of the resort development; however it was John who held a meeting in October 1867 to discuss the pier and the funding of the £6,000 that would be needed to pay for the construction. It was to be 1,500 feet long, made from iron piles and supports and timber decking, with shops at the entrance and a saloon at the head. The pier opened in 1869. The early years were successful: in 1870 the shareholders who had bought £5 shares to pay for the build received a dividend of 10 per cent. The success of this venture perhaps encouraged the building of the two piers at Redcar and Coatham; however, like these, the sea would show its force at Saltburn. In October 1875, the pier head and landing stage were washed away. Repairs were made but the pier was shortened by 250 feet leaving the iron piles of the isolated section standing alone in the sea and in need of removal. This brought a representative of the Nobel's Explosives Co. to demonstrate the power of dynamite. Nobel had patented the manufacture of dynamite in Britain during the 1860s – it was a new high explosive that used nitroglycerine. Unfortunately, nitroglycerine had the disadvantage of being known to explode spontaneously, which did little to encourage its use. Nobel managed to find a way of preventing this but there was still reluctance to use his explosive. Saltburn provided a chance to demonstrate its powers and superiority over gunpowder. Charges were placed out at sea and when detonated those watching from the clifftop saw a great wave of water thrown 40 feet into the air.

The town being on the clifftop brought comments from visitors that it was 'such a tiring place' and to go down to the pier and beach involved 'a certain amount of unpleasant jarring'. To make this easier a hoist was built in 1870. This was not a facility to be used by those fearful of heights as it involved walking out over the cliffs along a gangway to the hoist which was lowered vertically down the 120-foot drop to the pier entrance. The descent could be nerve-wracking – sometimes the mechanism stuck halfway down. By 1883 the hoist was considered to be unsafe, and it was replaced with the cliff lift that is still in use.

Another high-rise construction was the bridge above the valley gardens. It removed the need to tackle another climb and descent to make the trip from Saltburn to Skelton and beyond. This was the Ha' Penny Bridge named after the toll charge of 1/2d for a pedestrian to cross – the toll could rise to 6d for a carriage drawn by four horses. However, the main drive to build the bridge was to open up the land across the valley from Saltburn for development, but builders were not attracted. The bridge was built by Gilkes, Wilson and Co. and during the construction in 1869 disaster struck. Three workmen were stood at the top of a pillar, some 100 feet above ground, waiting to manoeuvre a girder that was being pushed across from the completed section of the bridge, when it fell, struck the pillar, and sent the men crashing to the ground.

The Ha' Penny Bridge was used for an early trial of a telephone system. In 1876, Alexander Graham Bell made a call on his first working telephone and a new age of communications was launched. He was in England in August 1876 demonstrating his latest version of his invention to a group of scientists in Plymouth. In the same month

H. A. Irving was laying a wire across Saltburn's Ha' Penny Bridge connecting telephones to the homes of Sir Francis Fox and Judge William Ayrton. Irving had heard of Bell's work and had developed similar equipment to use on this trial. Francis Fox, who was director of Bell Brothers Iron Masters, was so impressed that he arranged to extend the trial over a longer distance. To do this he had a telephone installed at the company's offices at the ironstone mine at Brotton and at the head office in Zetland Street, Middlesbrough. For much of the way the telephone link used the telegraph poles that stood along the railway line. Perhaps Saltburn can claim to have the first telephone system in the country.

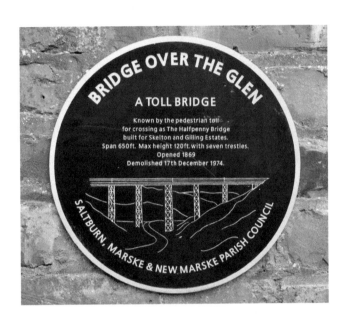

*Right*: This plaque is all that remains of the Halfpenny Bridge.

*Below*: An early twentieth-century view of Saltburn from the Halfpenny Bridge. (Courtesy of Beamish People's Collection)

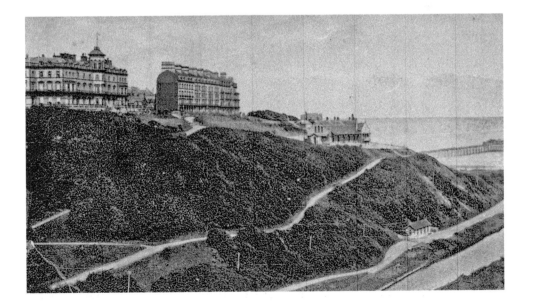

The impact of the economic depression that developed during the 1870s has already been seen in the strike and reduction in wages paid to the ironstone miners. There were much wider consequences; the downturn produced what one commentator called the 'terrible calamity that has overtaken the district'. Iron works were operating at a loss and eventually there were failures. By 1879 Gilkes and Hopkins and Co. were unable to continue trading, as were Messrs Lloyd and Co., another firm with blast furnaces. The management of both firms included Isaac Wilson and Edgar Gilkes who were also involved with the Saltburn Improvement Co. With so much difficulty in the manufacturing sector, the enthusiasm for the development of a seaside resort faltered. Then in 1881 Henry Pease died, taking away the driving spirit behind the development. His wife recorded that he felt 'a shade disappointed as years went on that Saltburn did not grow as rapidly as at first it seemed to promise to do'. Saltburn was left looking for new leadership. This came from the Saltburn Extension Co. formed by a group which included the owner of the *Middlesbrough Gazette*. Some housing continued to be built and as the nineteenth century faded the town had a range of houses for sale; a villa with three reception rooms, ten bedrooms, billiard room, cloak rooms, butcher's pantry, kitchens, conservatory, and motor house was on sale at £7,000. At the other end of the scale terraced houses with a bathroom could be bought for £330. By 1901 Saltburn had a population of 2,578, of which 58 per cent were female. This was above the national average – no doubt the domestic work available in the grand houses and hotels coupled with the opportunity that widows had taken to run lodging houses to earn a living there contributed to this imbalance.

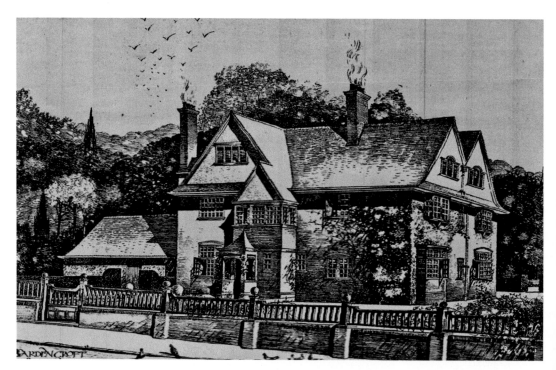

Badencroft built for William I'anson, civil engineer and manager of the Cleveland Water Company.

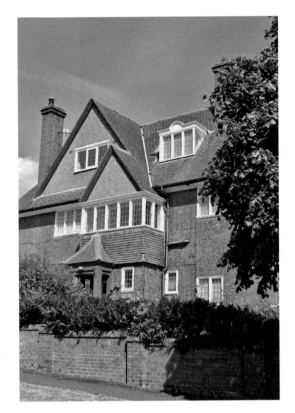

*Right*: Badencroft still stands among the grand houses built in Saltburn.

*Below*: Above the glen at Saltburn is Rushpool Hall, built with ironstone from the Skelton mine in 1864 for John Bell, a member of the family of industrialists Bell Brothers.

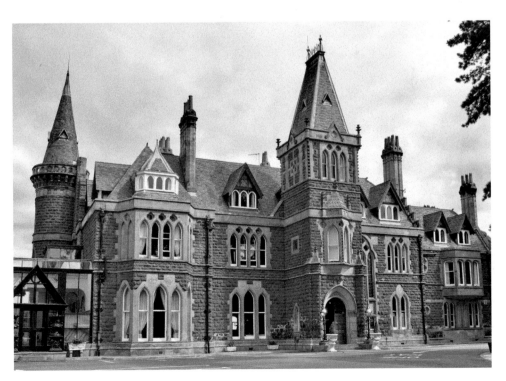

As the twentieth century arrived, attractions had been developed. The Assembly Hall had been built in 1884 and, between performances by touring companies, dances were held. There were brine baths with swimming lessons available in the 75 x 10-foot pool. Moving pictures were being shown in 1909. Easter 1909 saw the start of celebrations to welcome visitors at the start of the season. In the Valley Gardens, the 5th Lancers band were booked to provide concerts, a display was organised by Brocks fireworks, and Japanese lanterns would light up the gardens. Afternoons could be spent listening to the town's orchestra.

For holidaymakers, there was varied accommodation. A semi-detached villa with three reception rooms and six bedrooms was available during August of 1905 for 8 guineas per week. The Alexandra Hotel advertised rooms starting at 8/-(40p) per day, with a superior room with sitting room and bedroom available for 13/6 (67p). Breakfast was 2/-(10p), hot lunch was 3/6 (17p), and dinner was 5/-(25p). During the afternoon, tea with cakes was served at a price of 1/6 (7p). The Zetland had the luxury of having its own railway platform where trains pulled in from the main station.

The entertainment in the valley gardens and pier for the 1909 season.

# SALTBURN-BY-THE-SEA BRINE BATHS.

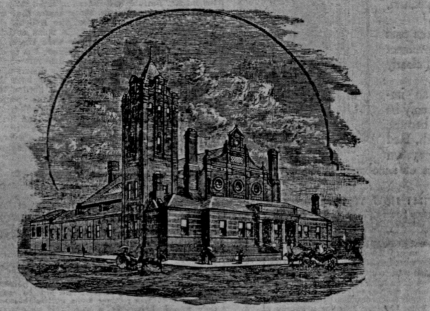

THESE BATHS, which are situated close to the Railway Station, have been erected specially for the Brine Treatment, which has been found so efficacious in the cure of Rheumatism, Gout, Lumbago, Sciatica, Neuralgia, Rheumatic Gout, Paralysis, etc., at similar establishments in the West of England. The BRINE is brought from Salt Wells in the neighbourhood, and is TEN TIMES AS SALT AS ORDINARY SEA WATER. In addition to the Brine Treatment, Massage, Electric and Vapour Baths, etc., are provided.

The Baths contain both a LADIES' and a GENTLEMEN'S Department, and will be open during the Summer as follows:—Week-days 7.30 a.m. to 7 p.m.; Sundays 7.30 a.m. to 10.30 a.m.

NEEDLE, VAPOUR, RUSSIAN, DOUCHE and ELECTRIC BATHS, as well as experienced MASSEURS, will be specially reserved for Ladies and Gentlemen previously notifying at the Office, or by letter, the time at which they will be required.

*Above*: The grand baths near the station in Saltburn.

*Right*: Bath Street no longer hosts the baths.

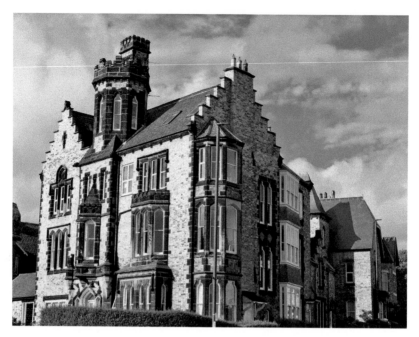

This was the Tower School at Saltburn which offered 'thorough modern education for girls' and provided opportunities for sport including tennis and sea swimming.

Visitors to the Zetland Hotel did not need to use Saltburn station as trains would pull into the hotel's own platform.

In the early years, the new Saltburn was not all about a holiday resort. Among the lodging house keepers, bathing machine proprietors, waitresses, tailors, plumbers and railway workers living in the town were quarrymen and miners. Deposits of ironstone were close by at Hob Hill, and by 1865 these deposits were being mined and quarried by the Pease business. In 1872, it was being reported that the bulk of the ore had been taken out, and by early 1875 the mine was closed.

DID YOU KNOW?
**Hob Hill, the Home of Hobgoblins and Demons?**
The Hob Hill Mine was reopened in 1902 and the extraction of ore was underway again. In 1909 graves were uncovered during quarrying works. William Hornsby, a local farmer and amateur archaeologist, excavated the site and recorded the finds. Amongst the burials were grave goods including spears, knives, pottery, beads of glass and amber, and brooches, all providing evidence of early settlers in the area dating to Anglo-Saxon times. Was this site known about in the distant past and led to some folklore that warned of the presence of death and burials in the area named as Hob Hill?

# 7. The Best of Times, the Worst of Times

The years between the wars are associated with economic depression, unemployment and the general strike, and it could be expected that the last thing people would be able to afford was a holiday. Paradoxically, the resorts were busy. Why was this and how did the three towns respond to this opportunity whilst dealing with the difficulties and hardship brought by unemployment, and in the case of Redcar, the additional problem of a chronic housing shortage?

During the First World War, Dorman Long had taken over the Redcar iron works and was commissioned by the Ministry of Munitions to build a new steel plant at Redcar to meet the production needed for the war effort. The plant was employing over 1,600 by 1917 and numbers were expected to reach 2,000 when fully operational. This brought more people into the town, but resources were not released to build houses. The census figures give some idea of the increasing numbers: in 1911 there were 10,503 people in Redcar, by 1921 there were 5,898 more, an increase of 56 per cent. In 1919 there were reports of families sharing houses, and others were living in huts, converted railway

Whilst Dormanstown was a new village, one building, Westfield House in The Green, dates from the eighteenth century.

wagons and tents. There was a desperate need for new houses and the government was demanding action to improve housing nationally. The medical examination of recruits during the war had revealed many unfit for service and the squalid living conditions that some faced contributed to this. Houses that were habitable had to be provided to make, as Lloyd George had promised, a 'land fit for heroes'. By the end of the war a new settlement was being heralded as a 'Garden City for Redcar', although it may have been better to describe it as a garden village. This was Dormanstown, developed by Dorman Long. From beginnings in the late nineteenth century when Arthur Dorman, a metal broker, formed a partnership with Albert de Long, a civil engineer, Dorman Long had developed into an industrial conglomerate owning iron and steel manufacturing plants, rolling mills, engineering businesses and coal and ironstone mines. Locally they had expanded by acquisition of some of the firms that had played such significant roles in the development of industry in Teesside, including Bell Brothers.

DID YOU KNOW?
The Garden City movement was a response to the dismal housing that had been built in the industrial towns which brought the rows of terraced houses built with little thought for fresh air, light and recreation. Garden cities provided a new approach to town layout: houses with gardens were laid out along avenues and crescents near parks and green spaces. Ebeneezer Howard is credited with starting this new way of planning towns, and the first to be built was Letchworth.

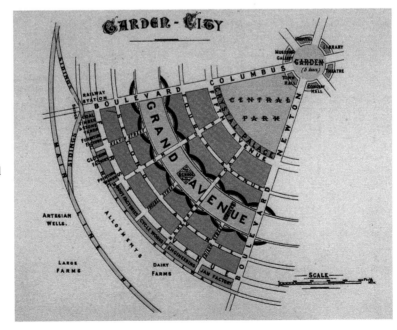

Ebenezer Howard championed the Garden City movement and outlined plans for towns that would move away from the poor layout that had developed in industrial areas.

Dormanstown provided an opportunity to avoid the poor conditions that were highlighted in Gertrude Bell's book *At the Works*. Three types of three- and four-bedroom houses were included in the original plans, all with the benefit of bathrooms and toilets. Dormam Long took the opportunity to use its newly developed Dorlonco building system using steel frames bolted to concrete bases. The walls were made of reinforced concrete with the steel reinforcements also supplied by Dorman Long.

The local council was also responding to the need for more housing and found a novel way of encouraging builders to develop a 30-acre site it owned. Government subsidies were available for housebuilding. Usually this was paid to builders; however, in Redcar this was used to fund the gifting of plots to builders. There was the condition attached that they should be affordable, none costing more than £350. In 1925 Redcar's Medical Officer of Health reported that 668 houses had been built since 1921 including 289 by the local authority and it was felt the shortage had been cleared. At Saltburn housing was not such a serious problem, but 106 new houses had been built since 1921, of which twenty-five were built by the council. The same theme was echoed at Marske where there had been little demand for housing development with only fifteen new homes built.

Nevertheless, the government continued to encourage the provision of better housing, and in May 1931 the first homes built by councils specifically for aged couples were opened in Dormanstown. During the opening ceremony Redcar council was praised as being a pioneer in the provision of homes for the elderly, and a telegram from the King thanking the residents for 'their loyal greeting and good wishes' was read out. The twenty bungalows were available for rent at 25p per week. More homes designed for older folk followed; in 1934, the Dowager Lady Zetland opened the Rosemary Cottages in Marske.

There was a boom in the years immediately after the First World War as resources that had been diverted to the war effort were released and losses, for example of shipping, were replaced. The coal mines had been taken under Government control and were handed back to the owners in 1921, just as the boom was ending – demand for coal for export fell as mines in Europe that had been closed during the war were reopened. The price fell, leaving owners searching for ways to remain competitive. One solution was to cut miners' wages, but this brought a strike that lasted three months. Disputes over wage rates rumbled on for years. the General Strike of 1926 lasted only days, but the miners action carried on longer. The end of the post-war boom brought unemployment. The iron and steel industry, on which much of the economy of Teesside and the surrounding district relied, was not immune. The ending of the war had brought large amounts of scrap steel to the market. Steel could not be produced at the price being paid for the scrap, and steel production plants were closed. Workers were made redundant and those left in work faced wage cuts. Production in ironstone mines throughout the country was cut back; it was reported that there were 8,000 ironstone miners out of work in November 1921. The demand for steel dropped as other industries contracted, shipbuilding being one example. In 1920, United Kingdom yards built around two million tons of shipping, but by 1932 it was down to 188,000 tons. Stockton on Tees was described as having 'shipyards that have been closed for years so that grass is growing on them ... and marine engineering shops are now empty shells'.

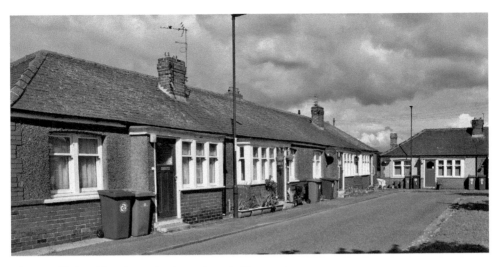

*Above and below*: The pioneering bungalows in Dormanstown.

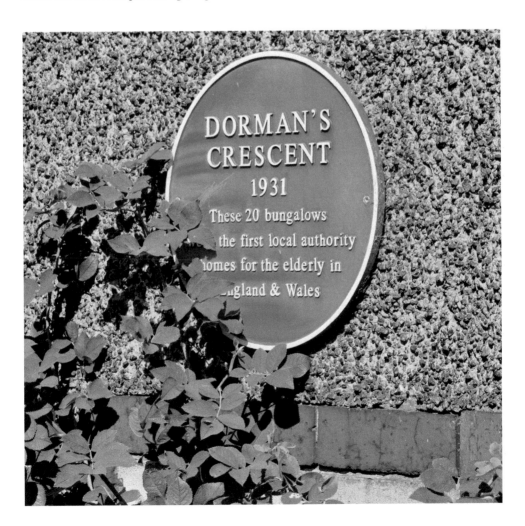

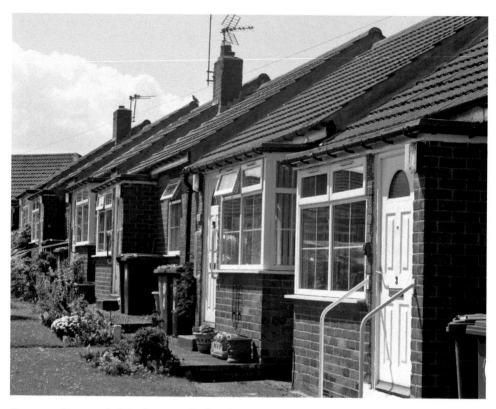

Rosemary Cottages in Marske, named after the Dowager Lady Zetland and her practice of giving visitors a sprig of rosemary.

The serious impact on families was highlighted by Redcar's Medical Officer. His report in 1925 told of unemployment which had continued at a high level since 1921 and meant 'a serious proportion of the population has been living for some years at or near bare subsistence level. The class which has visibly suffered most has been that of female adults.' The report produced for Saltburn also recognised the problem, although the relatively high employment of women provided a better picture. In Marske unemployment was high, not helped by the abandonment of the exhausted Upleatham ironstone mine in 1923. Some ex-miners were found work planting trees to landscape the hills that had been scarred with the mining operations.

The government started providing grants to local authorities in areas that were blighted by high levels of unemployment. These were to contribute towards the cost of schemes that provided work. Redcar qualified for this assistance and projects were worked on to improve the infrastructure, such as renewing gas pipes and providing all houses with toilets connected to the sewerage system. Road schemes were also supported by the Ministry of Transport; the Coast Road to Marske was built in 1923, and the Trunk Road to Middlesbrough opened up a direct route to Redcar. However, it was Redcar council's policy to spend heavily on developing the resort that was the most enterprising and potentially risky.

The wisdom of this might be questioned. In these difficult times surely the last thing people could afford was a holiday? However, this was not the case. Not everybody was out of work and many of those in work were starting to receive holiday pay. A holiday by this time was no longer a privilege of the wealthy; through the interwar years a holiday became the norm for many. In the late 1930s around fifteen million were taking at least a week's holiday, and as one writer was able to reflect in the 1940s, a holiday was 'saved and planned for during the rest of the year and enjoyed in retrospect when they were over'. Even those who could not afford a holiday may have been able to take a day trip away from the day-to-day world and Redcar became a popular destination for day trippers. However, the behaviour of some who ran wild was causing concern and brought the comment that 'some of the women from the pit country merely visit ... to indulge in a wet afternoon and make themselves a nuisance'.

Grants were sought by Redcar council during the 1920s to extend the promenade and pay for the landscaping of Locke Park with gardens, tennis courts, a bowling green and boating lake, which brought work for around 300 people in 1924. A park had also been provided on land donated by Lord Zetland. A major scheme for the resort was started in 1929 involving the provision of an open-air swimming pool, an indoor pool and a boating lake. This complex was ready for the 1930 summer season, all helping to further the council's goal of becoming a major resort. Coatham pier had been left to rot after the punishment it had from wayward shipping, but the council rescued the stub left at the landward side, adding a shelter over the entrance and later a 'glasshouse' which formed the new Pavilion theatre.

Locke Park was opened in 1930 on land gifted to Redcar by Thomas Locke, a local doctor who devoted much time to advancing the town including promoting the pier and the racecourse.

The approach taken at Redcar provided work and developed the facilities for holidaymakers and trippers. For those staying, there were hotels and inns available; the Coatham Hotel offered sixty rooms, dance floor and garaging all close to the amenities. At the other end of the scale, those wanting a holiday on a budget could find lodging in the homes of the unemployed, although if the authorities discovered they had been taking paying guests their benefits would be cut.

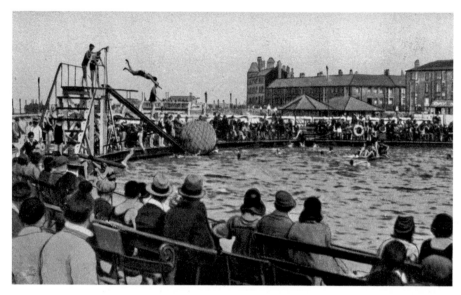

The open-air bathing pool, part of the interwar expansion of facilities for holidaymakers in Redcar.

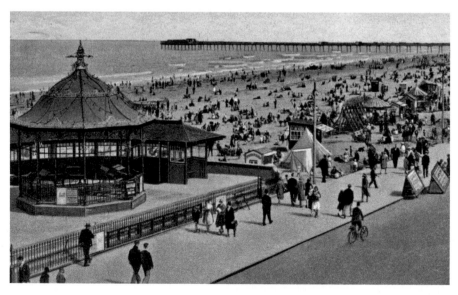

A busy day at Redcar. Along the promenade the pier was waiting for visitors.

During the 1930s the depression eased, and the town was able to portray itself as a modern resort. In 1932, the town's mayor proudly reflected on the achievements and the 'big schemes' that brought new parks, swimming pools and promenades. By 1938, Redcar was recognised as an enterprising holiday resort. The gamble of spending big had paid off.

Nevertheless, the growing attraction of the resort did not suit all. There were complaints that Sunday observance was being flouted when the boating lake was opened and games were allowed in the parks on Sunday.

Another development that was also causing unease was the ownership of motor vehicles, which brought complaints, particularly from those residents who found cars parked in front of their houses. In 1927, a local newspaper reported that cars were becoming a problem, particularly on bank holidays when traffic in Redcar was considered 'excessively heavy and precarious for all and sundry'. The motor coach was also starting to operate, which, along with the growing ownership of cars, began to threaten the position of the railways. United Automobile Services became one of the largest and started to run buses between Darlington and its depot at Redcar in 1920. Their vehicles were gradually developed, and by 1926 all United buses had pneumatic tyres. In 1928 the business' directors were confident enough to allow the maximum speed that drivers could reach to be increased from 12 to 28 mph. By 1925, the company was taking over other bus operators and brought Hemmingway of Skelton and its eight buses, Yeland of Redcar, and Smiths Safeway Services of Middlesbrough into the fold.

It was not only the council that was taking the opportunity to provide attractions; the beach had punch and Judy shows, donkey rides, swings and roundabouts and entertainment from concert parties. The town had three cinemas: on the seafront was the Esplanade, the Central Hall that had been built as the town's first railway station became the Central Cinema and nearby was the Regent. Between 1925 and 1938, the Redcar Pleasure Park on land off West Dyke Road operated an amusement park with roller coaster, skating rink and side shows.

United Automobile Services started operating in Lowestoft then expanded into the North East in the 1920s. (Courtesy of the Centre for Local Studies, Darlington Library)

# SALTBURN MOTOR SERVICES

——FOR——

# Private Party Excursions.

The latest type 30-seater Parlour Coaches, fitted with all the latest for passenger comfort, including high-backed seats with head rests, sunshine roof and luggage racks.

First class carriages at third class fares. Let us quote you. For enquiries apply to

## J. C. PICKERING,
## 4, Amber Street, Saltburn-by-Sea

Whilst United became a major operator, there were other bus services.

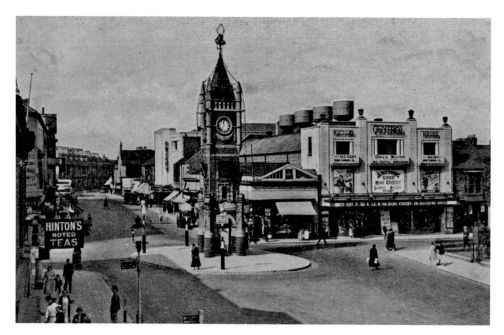

Redcar's Central Cinema, one of three in the town.

# CENTRAL HALL
## REDCAR
**6.40  TWICE  NIGHTLY  8.40**
### Week Commencing July 4th, 1927.

---

### Monday, Tuesday & Wednesday
### Her latest production

# Mary Pickford
— in —

# Human Sparrows
**Adventure and drama.  Suspense and thrills**
**Laughs and tears—and Mary Pickford.**
## NEWS FILM.
**Your Husband's Past  -  *Ideal Comedy***

In 1927, the Central Cinema was showing Mary Pickford's *Human Sparrows*, 'a story of adventure and drama'. Also showing was *Your Husband's Past*. One of the film's script writers was Stan Laurel, of Laurel and Hardy fame.

Did You Know?
Just before the First World War, two brothers arrived in England hoping to find employment that was more rewarding than tending olive trees in Italy. They travelled to the North East where they had relatives. One of the brothers settled in Middlesbrough and the other, Jacomo, started a café in Stockton on Tees. His son, Alfonso Pacitto, chose to continue in the catering business and opened his ice cream parlour in Redcar.

Saltburn was different. There was no attempt by the council to bring any significant development to the resort. The three grand hotels that had been built in the last century set the tone of the resort during the interwar years. In the mid-1930s Saltburn was the

place for those who sought 'the town's tranquillity and quietness ... at Saltburn you will find peace and rest'.

The town did not escape the problems of unemployment. The Hob Hill mine was closed by 1921, so many of those living in the town relied on work in adjoining districts in the iron and steel industry, although many were employed in commercial, clerical and transport occupations. In 1925, the Medical Officer of Health was able to claim that the standard of living was higher than in neighbouring districts. Nevertheless, local authorities in the resorts had to become involved in the development of facilities including entertainment, infrastructure and publicity as well as moulding the overall strategy for the development of the resort. Whilst Saltburn authority did not follow a similar policy to Redcar, eventually there was acceptance that the major facilities for holidaymakers would be better in the custody of the local authority. The council, after negotiations with the Middlesbrough Estate into whose hands the pier and the cliff tramway had fallen after the decline of the Saltburn Improvement Co., took them over.

Pacitto's ice-cream parlour – a taste of Italy?

# ELECTRIC *₊* THEATRE,
## DIAMOND St., SALTBURN.

—o—

## LONDON BIOSCOPE COMPANY,
### Showing the Latest Living Pictures.

### — 7 — TWICE NIGHTLY — 9 —
### Matinee, Saturday and all wet days.
### Change of Programme every Monday,
### Wednesday and Friday.

—o—

Prices :—First Seats 6d., Second Seats 4d., Sides 2d.
Seats may be reserved, 9d. each,
at Hamilton's Library.

Saltburn's cinema was operating in the Parish Hall in Diamond Street.

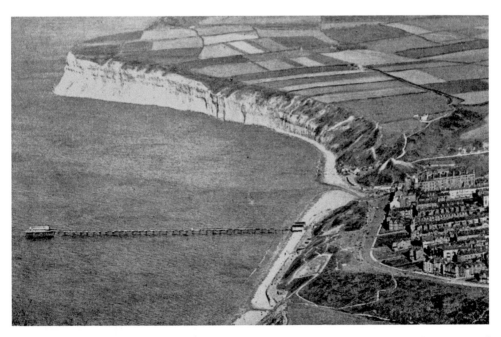

An aerial view of Saltburn with the pier longer than the 681 feet that has survived. (Courtesy of Beamish People's Collection)

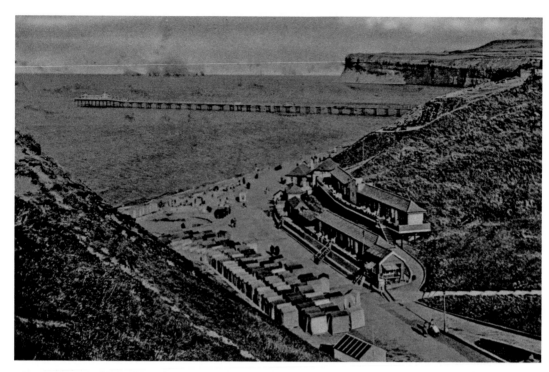

At the end of the Saltburn's promenade, Hazel Grove was a busy area.

Hazel Grove is now much quieter with the chalets removed.

Along at Marske the aerodrome that had brought so much activity continued as a training base in the immediate post-war years, closed down. The extensive surplus equipment from aircraft hangars to filing cabinets were offered for sale. Some businesses moved into the site including Hughes and Bolckow selling all manner of tools, lifting gear, and other army surplus. The site also housed a school between 1921 and 1927.

DID YOU KNOW?
Empire Day was celebrated every May from the early twentieth century until mid-century, by which time the British Empire was starting to become irrelevant. It was a festival designed to engender and develop the qualities of loyalty and patriotism in schoolchildren who were to grow and become part of the great empire. In school, lessons would be abandoned for the day and children would parade in the school yard and sing patriotic songs such as 'Rule Britannia'. At the Marske aerodrome school in May 1923, the children were also able to look forward to a gramophone concert!

There was little development of facilities for holidaymakers at Marske, leaving the beach to attract visitors. Cliff House was bought by the Holiday Fellowship, who converted it to become one of their establishments providing inexpensive holidays. Camping became popular and the fields around the town were used. The amalgamation of the local authority with Saltburn did allow the two towns to portray their attractions for visitors and encourage those looking for a holiday which provided 'lovely gardens, glorious sands, a background of moors, golf course, brine swimming baths and pier fishing'.

DID YOU KNOW?
The vicar at Marske, Albert Waton, hit the headlines in 1935 when he opened St Germain's Church on Sunday evenings and encouraged visitors who had spent the afternoon on the beach to attend. Trying to show that Sunday best was not obligatory, he joked that bathing costumes could be worn. He soon received letters from parishioners who did not see the funny side. The national press got hold of the story and Marske hit the headlines, the *Daily Mirror* reporting 'Bathing Suits for Church'.

Before long, war threatened, air-raid shelters were built and children were evacuated to homes around Marske.

The common room at Cliff House which was bought by the Holliday Fellowship to provide holidays away from 'thoughtless spending of money, inane amusements and crowded lodging houses'.

# 8. On the Beach

The beach is a major draw that brings people to the coast for a holiday. It is a different, liminal place, a place to walk by the edge of the sea, a place of amusement. However, it provides a different experience for those who use it for their work; then, it is the edge of danger.

The long stretch of beach in front of the three towns brings a collection of stories. In 1811 bathing machines were available at the water's edge. These protected the modesty of visitors and ensured that 'ladies and gentlemen can be completely hid from each other'. Using a bathing machine was an involved process. The machine was a wooden cabin mounted on wheels, and inside was a bench, with some light filtering through a small window. The bather would climb a few steps into the cabin and change into swimming clothing, then the machine was pulled into the sea, often by a horse harnessed to it, and the bather could then climb down the second, lower, set of steps and the other end of the cabin into the sea. After swimming, the process was reversed; the bather climbed back into the cabin, the machine was brought back to land, clothes were changed, and the bather stepped out in day clothes.

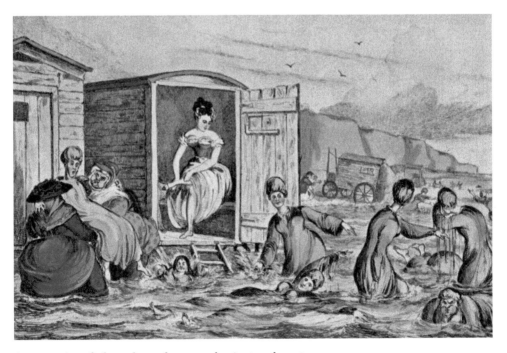

An engraving of a busy day at the sea, early nineteenth century.

As a trip to the coast became a treat for more and more people, entertainers were drawn to the beach. Donkey rides, Punch and Judy shows, jugglers and, from the 1880s, concert parties appeared at Redcar. They performed on boards laid on the sand, giving three or four shows a day. One of the cast would work through the audience, encouraging them to put a few coins into a collection box. The Cleveland Cadets were often at Redcar in the years before the First World War. During the interwar years, Billy Scarrow became a regular attraction. In the 1920s, he brought a Pierrot troupe to the Coatham pier 'Glasshouse'. Then, between 1931 and 1939, the Billy Scarrow Optimists performed on the beach. Out of season, Billy, who was based in Redcar, continued to entertain but had to move around the country performing in musical revues and pantomimes. In January 1926, he was in *Babes in the Wood* at Mexborough Hippodrome. A review explained how 'Billy Scarrow (Demon Avarice) and Tom Robinson (Demon Darkness) join forces in a splendidly rendered item which earns great appreciation'. The pantomime over, the two were looking for more work and placed notices in the trade press explaining, 'those popular duellists Billy Scarrow, Tenor and Tom Robinson, Baritone are vacant from 5th February. Always a great attraction'. As the holiday season approached, Billy would advertise for pianists, comedians and other entertainers to join his troop of Optimists.

Along the beach at Saltburn, Grapho and Jackson's Jovial Jollies were popular for many seasons between 1899 and 1939, first performing on the beach and then on the promenade where the expensive seats (deckchairs) were placed close to the stage.

However, the beach has been the place of much more activity. The exploits of smugglers unloading their contraband have already been described. Many of those involved in the trade would no doubt have been fishers. Fishing has been part of the three towns for centuries. The monks at Fountains Abbey had a fishery at Coatham and those from Guisborough Priory were recorded as taking fish. During the Middle Ages, the activities of the fishermen and women at Redcar were documented. Cobble boats were carried across the beach and taken out to sea by fishermen who endured storms that kept them at sea for days, although the greatest danger was described as being near home, where the waves break dangerously and the fishers have to row to mount them whilst women and children waited at the sea's edge to help if the boat capsized. There was an annual festival where the cobbles were decorated, the mast was painted, and 'good liquor' was sprinkled across the bows, all no doubt to preserve good fortune for another year. By the nineteenth century, visitors watched the cobbles set out to sea to bring back fish to be sold on the beach. Others launched their boats and waited offshore to function as pilots to guide the sailing ships safely into the Tees.

The area did not escape conflict during the civil wars. A battle was fought between Royalists and Parliamentarians at Guisborough in the winter of 1642. Sir Hugh Cholmeley marched his men across the moors from Whitby to face Sir Guilford Slingsby, the Royalist who was believed to be preparing an attack on Whitby. William Pennyman of Marske Hall was a staunch supporter of the King. He raised a regiment that fought at the Battle of Edgehill and became governor of Oxford, the King's stronghold. William died in 1643 from the plague, and his uncle, James Pennyman from Ormesby, who also supported the Royalists, watched over things in Marske. With his men, he had to fight off Parliamentary

Billy Scarrow and his Optimists were regular entertainers at Redcar in the 1930s. (Courtesy of Neil Scarrow)

Fishing has long been associated with the towns.

troops who had arrived on board ships and attempted to land on the beach at Marske, perhaps in a bid to take over Marske Hall after William's death.

Moving goods around the country was difficult on roads that were often poorly maintained. Ships provided a better alternative for those living near the coast. With no port between Coatham and Saltburn, the vessels were loaded and unloaded on the beach. Ships were brought into Coatham at high tide, although they were then left high and dry and waiting for the tide to turn before they could be re-floated. Early trading from the port would have been with salt. The evaporation of salt had gone on for centuries, the monasteries at Guisborough, Rievaulx and Handale all taking salt from Coatham. The monks at Guisborough also used Coatham to have goods shipped in. Later, lime was brought for the local farmers, and Sir Charles Turner had a granary built for storage of grain brought from local farms to be loaded onto the boats for export.

The beach brought some trade to Saltburn in the eighteenth century. Timber was cut and shipped out whilst lime was unloaded to be used by farmers, but this was not the main enterprise; alum was a trade that brought rewards. Alum crystals, used to fix dyes in woollen, silk and linen fabrics, were a vital part of the textile industry. Tanners also found it useful in producing subtle leather.

DID YOU KNOW?
The Pope had controlled the production of alum, but the break from Rome by Henry VIII removed the need to respect this tradition and manufacture was brought to England, by Thomas Chaloner of Guisborough. Producing alum was a skilled job that needed considerable experience and the story was told that Thomas bribed some of the Pope's workers to travel to England and bring their knowledge to his alum manufactory. In order to avoid detection by the Pope, the men were smuggled from Italy hidden in barrels.

Alum was produced above Saltburn in the seventeenth and eighteenth centuries. The production was a long and involved process which began with quarrying alum shale and stacking it until a pyre of the shale covered with bush wood and coal was built. These heaps could reach as high as 80 feet before being set alight and left to burn for up to a year. If the decision to break open the smouldering pile was made at the right time, the burnt shale was ready for the next stage. This involved soaking the shale to produce a solution that could be evaporated to leave the finished product, alum crystals. Part of the process required an alkaline to be added, which could be in the form of kelp, seaweed or urine. Barrels were left on street corners in London and Hull to be filled. Those taking chamber pots to fill the barrels would explain that they were just 'taking the piss'.

The alum works along the coast at Kettleness. (George Walker, 1814)

The beach was the setting for horse racing by 1869. There were no barriers or railing to keep the charging horses separated from the crowds gathered on the beach, and in May 1869 a boy was injured as the horses raced by. There was no charge for those watching on the beach, and consequently, there was little prize money available. To remedy these problems, a properly laid-out course was needed where entrance fees could be charged. In 1872, land was found for a racecourse, and it was made ready for racing by August. Race meetings were a popular attraction for holidaymakers and day trippers. It could be a grand occasion, and Lord Zetland at Upleatham and William Lowther at Wilton Castle would take the opportunity to hold house parties. At the other end of the scale, rogues were attracted. In 1880, police were on the hunt for bookmakers who took bets then disappeared whilst the race was underway. Others took bets and issued betting slips, then brought out slips with different designs and denied all knowledge of any wagers.

A Race meeting was held at Redcar on 12 and 14 August 1939. As usual, excursion trains were running bringing crowds to the course. Days later war was declared, and racing resumed in August 1945. (Courtesy of Teesside Archives)

**4·30**

### FIFTH RACE.

**THE COATHAM HANDICAP**, a Plate of 200 sov.; the second to receive 30 sov. and the third 20 sov. out of the plate; for three yrs old only; lowest weight not less than 6st 10lb. a winner, after the publication of the weights (August 3rd, at noon), to carry 7lb. of two races, or of one value 180 sov., 10lb extra, entrance 2 sov., and 1 sov. extra for starters; **Five Furlongs, Straight** (30 entries).—Closed July 11th, 1939.

**FIVE FURLONGS**

|   | | st. | lb |  |
|---|---|---|---|---|
| 1—CHARMING HOPE | Mr A. E. McKinlay | 9 | 7 | yellow, pink sleeves, qtd cap |
| b. c. by Le Becau—Emeraude (bred in France) | | | | (H. D. Peacock) |
| 2—ENGLISH ARCHER | Mrs L. Hyman | 9 | 6 | maroon, gold and turquoise stripes, hooped cap (T. Hall) |
| b. c. by Bold Archer—Bold Front | | | | |
| 3—ALLOY | Mr J. W. Waller | 9 | 0 | Navy blue, flame sash, stripe on sleeves and cap (T. Hall) |
| ch. f. by Allazah—Crock of Gold | | | | |
| 4—SCOTTISH ARCHER | Mr J. H. Thompson | 9 | 0 | black, white sleeves, light blue cap (Webb) |
| br. c. by Bold Archer—Glenaffaric | | | | |
| 5—WILD LAVENDER II | Mr James V. Rank | 8 | 13 | Royal blue and primrose (qtd), primrose slvs, Royal blue cap |
| ch. f. by Mr Jinks—Lavendula II | | | | (N. V. S. Cannon) |
| 6—CAUTIOUS | Mr C. Featherstone Coles | 8 | 12 | crimson, green crimson & black hooped cap (Bisgood) |
| b. g. by Link Boy—Prudence | | | | |
| 7—EPIC | Lady Balli | 8 | 10 | flame red, old gold collar, cuffs and cap (O. M. D. Bell) |
| b. c. by Epinard—Colin | | | | |
| 8—MADAM ELEANORA | Mr F. W. Dennis | 8 | 10 | blue and white (halved), red sleeves and peak (Storie) |
| ch. f. by Loaningdale—Joyous | | | | |
| 9—SCHERZOLINE | Mr W. Davis | 8 | 8 | blue, white spots, blue sleeves |
| b. c. by Scherz—Slenderline | | | | (E. Fox) |
| 10—ARISTARCHUS | Mrs E. R. Houghton | 8 | 8 | maroon & grey (qtd), one grey one maroon sleeve (Bazley) |
| b. c. by Lennarchus—Thracian Girl | | | | |
| 11—PARCHMENT | Mr W. H. Thorpe | 8 | 8 | old gold & scme stripes, old gold slvs, qtd cap (M. J. Peacock) |
| ch. c. by Apelle—Polly Flinders | | | | |
| 12—GILLING | Mr R. L. English | 8 | 8 | violet |
| b. c. by Bold Archer—Su Kwang | | | | (Davey) |
| 13—EFETA | Mr J. D. Robertson | 8 | 7 | Robertson tartan, white sleeves, collar, cuffs & cap (Barling) |
| gr. f. by Stefan the Great—Newt | | | | |
| 14—DOLMA | Mr James V. Rank | 8 | 6 | Royal blue and primrose (qtd), primrose slvs, Royal blue cap |
| b. f. by Dastur—Aldetta | | | | (N. V. S. Cannon) |
| 15—CALLIMACHUS | Mr J. Gorman | 8 | 6 | chocolate, lozenge hooped sleeves (Snayd) |
| gr. c. by Coroado—Orexa | | | | |
| 16—BAD LIE | Mr E. Davey | 8 | 4 | cardinal, white striped sleeves, hooped cap (Davey) |
| gr. f. by St. Andrews—Lady Puttenden | | | | |
| 17—PANCHA | Mr Leo Partridge | 8 | 3 | scarlet, black cross-belts, collar and cuffs, black cap with red hoop (H. M. Hartigan) |
| ch. f. by Gold Bridge—Diomedia | | | | |
| 18—EIGHT BELLS | Mrs A. Smith-Bingham | 8 | 2 | light blue, black spots, light blue cap (R. J. Colling) |
| ch. f. by Beresford—Chichester Chimes | | | | |
| 19—FILBERT | Sir Hugo Cunliffe-Owen | 8 | 1 | grass green, white hooped slvs, qtd cap (O. M. D. Bell) |
| ch. g. by Diomedes—Filastic | | | | |
| 20—MISS MATILDA | Col. W. F. Story | 8 | 1 | chocolate, Eton blue slvs, cross-belts and cap (Elsey) |
| b. f. by Truculent—Miss Matty | | | | |
| 21—TAKE A DOSE | Mrs C. Brotherton | 8 | 1 | blue and silver chalcedi, blue sleeves, scarlet cap (Renton) |
| gr. f. by Doctor Dolittle—Rosenvale | | | | |
| 22—VINCIT VERITAS | Mr H. Lawson | 8 | 1 | blue bird's-eye, yellow sleeves, red cap (Hamnett) |
| ch. f. by Tolgus—Arrabiyeh | | | | |
| 23—KATMANDU | Mr H. Thorpe | 8 | 1 | dark blue, pink cross-belts |
| br. f. by Concerto—Gold Leaf II | | | | (Binnie) |

Continued on next page.

---

| 24—BEAUMARIS | Mr F. Ferrier | 8 | 1 | orange & black (halved), hooped sleeves, black cap with orange peak (G. R. Sadler) |
|---|---|---|---|---|
| b. f. by Beaudelaire—Archerstown | | | | |
| 25—SUGARCANE | Mrs Duncan Potter | 8 | 0 | white, Duncan tartan hoop, armlets and cap (M. Vasey) |
| gr. f. by Felstead—Snere Royal | | | | |
| 26—LUCY LOVELY | Mr R. Dand | 7 | 12 | black and white hoops, crimson sleeves, purple cap (Dines) |
| ch. f. by Hill Cat—Belovely | | | | |
| 27—MARYPORT | Mr E. Chisnell | 7 | 11 | blue, black sleeves, sash and cap (Stratton) |
| br. f. by Portlaw—Saddleback | | | | |
| 28—LAVANT'S PRIDE | Mr J. Ismay | 7 | 5 | black, green hooped sleeves, gold star, green cap (Smallwood) |
| ch. f. by Winalot—Tramond | | | | |

★ Entered by telegram, and not yet confirmed.

**5·0**

### SIXTH RACE.

**ONE MILE**

**A MODERATE PLATE** of 200 sov., for three yrs old and upwards that, up to the time of closing, have neither won a race value more than 140 sov., nor more than three races; three yrs old to carry 8st 4lb, four and upwards, 9st., mares and geldings allowed 3lb; horses that have not won a race of a mile or over since 1937 allowed 5lb, and maidens, 7lb in addition; the winner, at any time, of a race of a mile or over to carry 7lb extra; the second to receive 30 sov. and the third 20 sov. out of the plate; entrance 2 sov., and 1 sov. extra for starters; **One Mile, Straight** (21 entries).—Closed June 27th, 1939.

|   | | age | st. | lb |  |
|---|---|---|---|---|---|
| 1—YORKSHIRE WOLDS | Mr J. T. C. Burn | 6 | 9 | 7 | green, gold sash, red cap |
| b. h. by Le Voleur—Safe Home | | | | | (Bowser) |
| 2—BROADSWORD | Mr W. F. Egerton | 5 | 8 | 11 | straw, black sleeves |
| br. g. by Schiavoni—Blue Steel | | | | | (K. W. Armstrong) |
| 3—KNOCKLAYD | Ld Glentoran | 5 | 8 | 8 | primrose, purple hooped cap |
| b. g. by Sandwich—Glennakerin | | | | | (M. J. Peacock) |
| 4—GREENROOM | Mr Arthur James | 4 | 7 | 13 | lilac |
| ch. g. by Pick of the Circus—Verdite | | | | | (G. S. Colling) |
| 5—CA CANNY | Mr S. Mortimer | 4 | 7 | 13 | cerise, black striped slvs, black collar, cuffs & cap (Bladon) |
| b. c. by Cameronian—Lightstep | | | | | |
| 6—TALLBOY | Sir Charles Hyde | 3 | 7 | 6 | white, gold diamond back and front, hooped sleeves, red cap |
| ch. g. by Apron—Taslon | | | | | (Scobie) |
| 7—FILLE D'ORIENT | Mr R. C. Sturdy | 3 | 7 | 3 | cream, pale green cross-belts & cuffs, hooped cap (Sturdy) |
| ch. f. by Singapore—Fille d'Amour | | | | | |
| 8—PETER GRAY | Mr L. Brook | 3 | 7 | 3 | black, green sash, red cap |
| gr. g. by Delius—Brood | | | | | (Maxou) |
| 9—ORMO | Sir Thomas Dixon | 3 | 7 | 3 | peach, cherry sleeves, primrose cap (M. J. Peacock) |
| b. f. by Orwell—Lisdoon | | | | | |
| 10—MAT | Mrs R. C. Fairfax | 3 | 7 | 3 | scarlet, black hooped slvs, scarlet cap with black spots (Elsey) |
| br. g. by Forerunner—Merry Lass | | | | | |
| 11—CORYLUS | Mrs W. P. Ahern | 4 | | | sea green, mauve collar and cuffs, qtd cap (B. M. Bullock) |
| ch. c. by Alcyon—Catalpa | | | | | |
| 12—PORTRAY | Mr W. J. Bellerby | 4 | | | cherry, white sash, hooped slvs |
| ch. g. by Portlaw—Solvox | | | | | (Bellerby) |
| 13—GAUTAMA | M. M. Boussac | 3 | | | orange, grey cap |
| b. c. by Bunstar—Sahmine | | | | | (Donoghue) |
| 14—ROYAL OAK | Mr E. E. Dixon | 4 | | | shot green, with flame qtd cap |
| gr. c. by Royal Minstrel—Acorn II (U.S.A.) | | | | | (Mercer) |
| 15—LAVANT'S PRIDE | Mr J. Ismay | 3 | | | black, green hooped sleeves, gold star, green cap (Smallwood) |
| ch. f. by Winalot—Tramond | | | | | |
| 16—★EFETA | Mr J. D. Robertson | 3 | | | Robertson tartan, white sleeves, collar, cuffs & cap (Barling) |
| gr. f. by Stefan the Great—Newt | | | | | |

★ Entered by telegram, and not yet confirmed.

Two of the races on 12 August 1939. In the Moderate Plate at five o'clock Knocklayd would be a good bet. (Courtesy of Teesside Archives)

The declaration of war transformed the beach. Defences were built and sections of piers were removed to prevent the enemy using them as landing stages. (Courtesy of Beamish People's Collection)

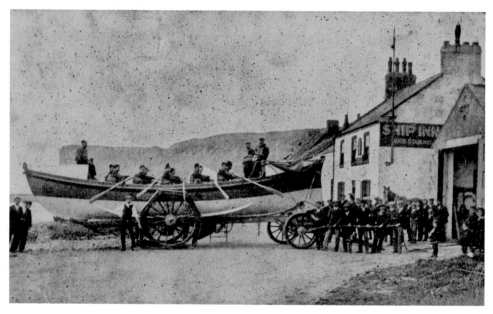

Saltburn Lifeboat. The lifeboat house near the Ship Inn has been demolished although the nearby mortuary still stands. (Courtesy of Beamish People's Collection)

Whilst horse racing was taken from the beach along at Saltburn, a new form of racing arrived: speed trials for the new motor cars. In 1905, the long stretch of beach around Saltburn attracted drivers in Daimler, Talbot, Rolls-Royce and Vauxhall cars to power along the beach trying to set speed records. This became an annual event, filling the town and its hotels with spectators and enthusiasts. In the early years, speeds of up to 125 mph were recorded along the track, which started near Marske and ended well before the pier, giving plenty of space for braking. In 1924, Malcolm Campbell brought his powerful 350-horsepower Sunbeam 12 to Saltburn and achieved 145 mph. This would have set a record, but unfortunately, the official timing equipment failed. Motorcycles were also racing along the sands by 1921. The event had a chequered history. It was moved to Coatham in 1938, where it was concluded that the sand was better. It was abandoned during the Second World War when the beach was closed and restarted in 1946 after the beach was cleared of mines. The last events, during the 1960s, were only for motorcycles.

A Napier motor car raced at Saltburn in 1908. (Courtesy of Beamish People's Collection)

In June 1907 Lee Guinness was credited with reaching 112 mph at Saltburn despite the torrential rain which left him speeding through 'sheets of water'. He was back in 1909 breaking the British speed record, this time reaching 120 mph. (Courtesy of Beamish People's Collection)

Robert Blackburn built an aircraft in his workshop in Leeds and, in April 1909, brought it all the way to the beach at Marske to see if it would fly. He managed to gather enough speed to lift the plane into the air, and the flight lasted about a minute before Robert crashed to the ground. Not to be deterred, he persevered, and The Blackburn Aeroplane Co. was building aircraft for the military during the First World War. This was not the only aircraft on the beach. In December 1912, there was a fatal accident at Marske as Edward Petri attempted to land his aircraft during a storm. He had been trying to fly nonstop from Brooklands aerodrome in Surrey to Edinburgh, but the poor weather forced him down onto the beach.

In August 1931, a 'big airliner' was giving flights from Marske beach. This was a Handley Page aircraft that had been flying on the European routes of Imperial Airways and boasted carrying 40,000 passengers before arriving at Marske. There was also a smaller aircraft that gave stunt flights to those who were brave enough.

In June 1909, suffragettes arrived in Redcar. They were attracted to the town by a by-election in Cleveland, which was the result of the sitting MP, Herbert Samuel, being given a cabinet position in Herbert Asquith's Liberal government. An ancient law required a by-election when an MP was promoted to the cabinet, a practice that would be stopped by 1923. Samuel was first elected in 1902, defeating the Conservative candidate. There had been no contender for the Independent Labour Party despite Keir Hardie organising a conference in Guisborough of trade unionists and representatives of labour organisations to select a Labour candidate. Keir wanted to improve the lot of working

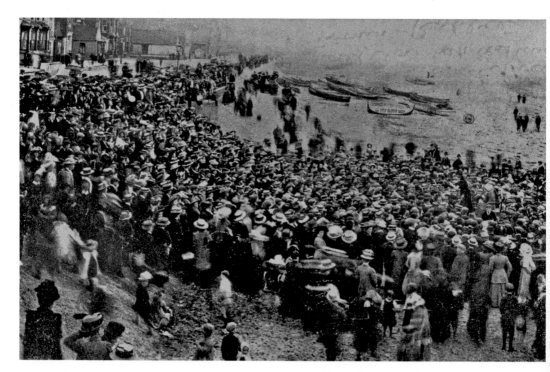

Suffragettes on the beach at Redcar in 1909. (Courtesy of Beamish People's Collection)

people and had been amongst those who brought about the founding of the Labour Party. However, the Liberals had become the party supported by the working class, and Keir could not persuade the gathering to select somebody to represent Labour. Keir Hardie left, complaining that they had chosen to support a young, rich gentleman. He was back in Marske in 1912 at a miners' gala.

At any election, suffragettes from Emmeline Pankhurst's Women's Social and Political Union (WSPU) took the opportunity to campaign against the Liberal government, which would not support their cause. In July, they arrived in force in Redcar, and Adela Pankhurst, Emmeline's daughter, spoke to a crowd gathered on the beach. Mrs Pankhurst also arrived in Redcar from London accompanied by more supporters, including Flora Drummond, another WSPU leader, and spoke at the Central Hall before continuing the campaign against Samuel throughout the constituency. Within days Mrs Pankhurst was in London and was one of 116 arrested for disturbances around parliament. Adela went on to Edinburgh, where the police removed her when she tried to disrupt a meeting being addressed by Winston Churchill. Herbert won the election but with a reduced majority. Whether the suffragettes had an impact is difficult to tell as there were many other issues, including the introduction of the eight-hour day for miners and, as one commentator noted, there could have been opposition to Samuel's support of the introduction of the tax of three pence per gallon on petrol. He did comment that no suffragette had been sent to prison for demanding the vote. This was not to last. Magistrates had not usually imposed prison sentences but bound them over to commit no further breaches. The women refused and chose to go to prison, which brought them the publicity that the cause needed. There was an escalation in September when Marion Wallace went on hunger strike in prison, which prompted the horrific force-feeding.

A few months later Samuel was swept out to sea whilst swimming at Saltburn. He could not make headway against the current and was struggling to make it back to the beach. Fortunately, he had been spotted from the pier and was rescued.

# Acknowledgements

My thanks for all the help and assistance I have received from those at Teesside Archives, the North Yorkshire Record Office, the Centre for Local Studies at Darlington Library, Beamish Museum and the British Library. I am also grateful to Neil Scarrow for the use of the pictures of his grandfather and the Optimists. Finally, a special thank you to Melanie Morris for her invaluable help editing the text.

# Also From Amberley

THE

# GOLDEN AGE

OF

# YORKSHIRE

# RESORTS

1800-1914

**GEORGE SHEERAN**

A fascinating exploration of the history of coastal resorts in Yorkshire catering for the well-to-do in their Victorian and Edwardian heyday.
9781398113459
Available from www.amberley-books.com
or by calling (+44)1453 847800.

# ILLUSTRATED TALES OF
# YORKSHIRE

### DAVID PAUL

The beautiful county of Yorkshire is one of the most visited in England.
Here is a collection of strange tales and local legends.
9781445689968
Available from www.amberley-books.com
or by calling (+44)1453 847800.